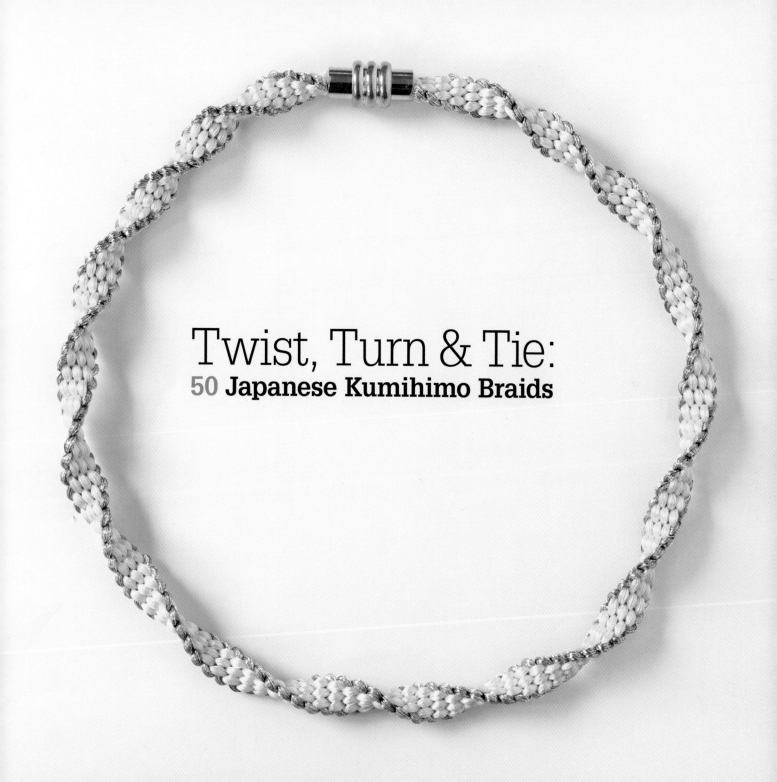

Twist, Turn & Tie:
50 Japanese Kumihimo Braids

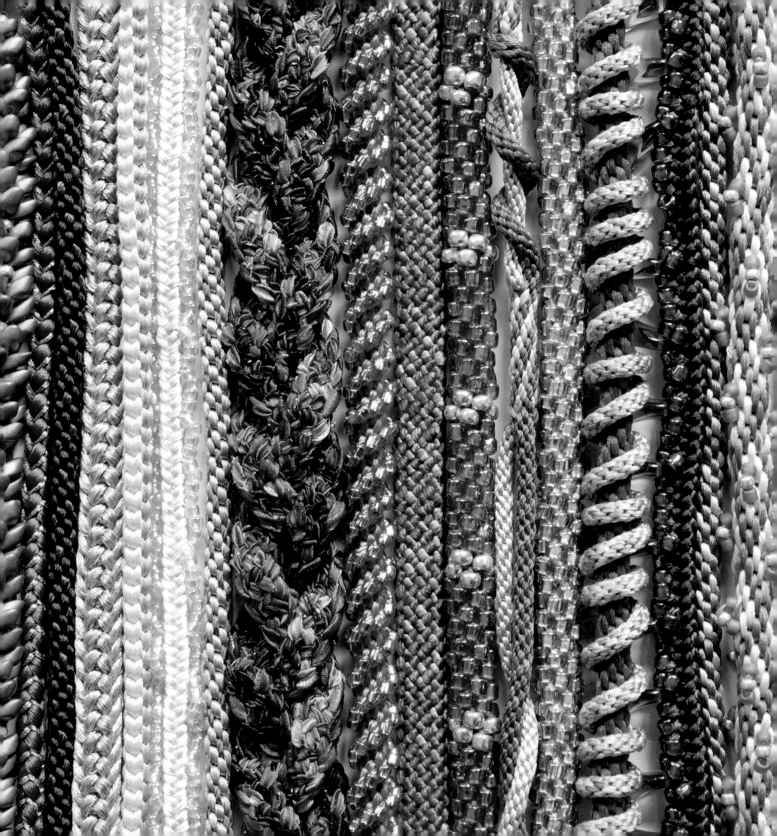

Twist, Turn & Tie:
50 Japanese Kumihimo Braids

Beth Kemp

BARRON'S

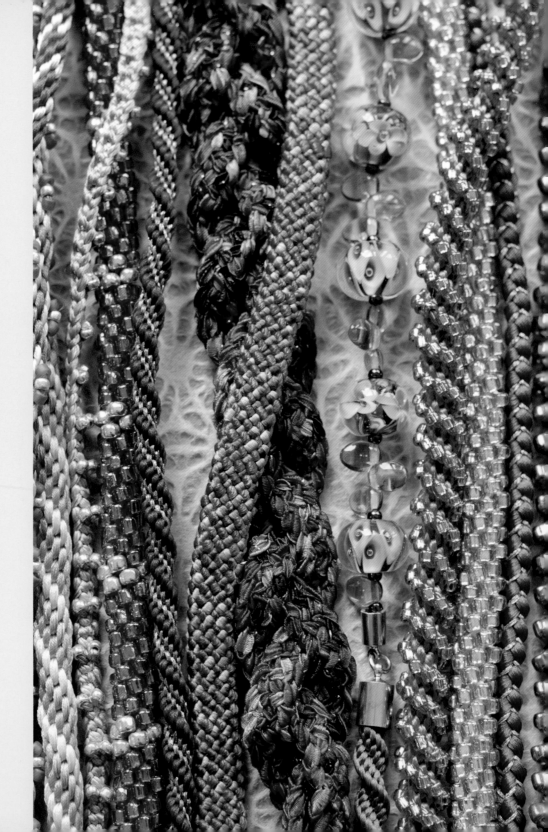

A QUARTO BOOK

For Georgia, Jasmine, Ella, and Willow

First edition for North America published in 2014 by Barron's Educational Series, Inc.

Copyright © 2014 Quarto Inc.

All inquiries should be addressed to:
Barron's Educational Series, Inc.
250 Wireless Boulevard
Hauppauge, New York 11788
www.barronseduc.com

ISBN: 978-0-7641-6643-3

Library of Congress Control Number:
2013953376

QUAR.BBKU

Conceived, designed, and produced by:
Quarto Publishing plc
The Old Brewery
6 Blundell Street
London N7 9BH

Senior Editor: Ruth Patrick
Art Editor: Emma Clayton
Designer: Tanya Goldsmith
Illustrator: John Woodcock
Photographers: Laura Forrester,
Phil Wilkins.
Proofreader: Sarah Hoggett
Indexer: Helen Snaith
Picture Researcher: Sarah Bell
Art Director: Caroline Guest

Creative Director: Moira Clinch
Publisher: Paul Carslake

Color separation by
Pica Digital Pte Ltd, Singapore
Printed by
1010 Printing International Ltd, China

9 8 7 6 5 4 3 2

contents

Foreword

I am delighted to share the story of my involvement with kumihimo, the Japanese art of braiding.

My love of braiding and beading comes from a background in the prestige jewelry industry. Ten years ago, I was introduced to kumihimo by international guru of braiding, Makiko Tada from Japan. Now I'm hooked!

My fascination for kumihimo has inspired me to develop my own designs and patterns for the kumihimo disk and plate, and to write my first book, called *How to Kumihimo*.

With the advent of the kumihimo disk, braiding can be done by anyone, any age, anywhere. Even standing in line at a beading or craft show. It's also one of the few crafty things that can be done onboard a plane.

The luscious silks and unusual beads that are now available are just waiting to be transformed into unique fashion accessories, either as jewelry, a belt, or something for the home. The possibilities are endless.

My aim with this book is not only to inspire you with the 50 projects and beautiful photographs, but also to give you a reference book that unlocks the mysteries of Japanese braiding. I hope you enjoy making the projects as much as I have loved creating them.

Happy Braiding,

Beth

Beth Kemp

Check out my blog "Kumi Talk" and newsletter "Kumi Kapers" on my website www. braidandbeadstudio.com, and Facebook page "How to Kumihimo with Beth Kemp."

About This Book

This book offers a wonderful collection of how-to braid projects created on a kumihimo loom. Core information at the beginning introduces the looms and threads. This is followed by the project section, organized into plain braids, beaded braids, square disk braids, and braids using fancy knots.

CHAPTER 1: Getting Started (pages 8–33)

This section introduces you to the types of disk, threads, and beads; there are articles to help with making color choices and designing your own braids and hints for figuring how much thread you will need before you begin. The step-by-step instructions walk you through the key techniques, from threading a loom and adding beads to finishing off with a range of findings.

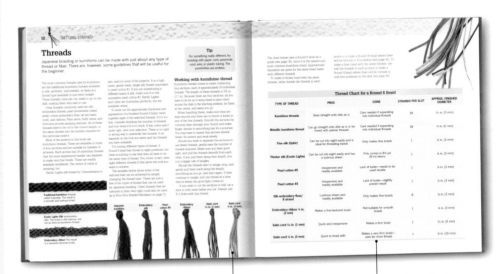

Introduction to threads
Different threads are described and illustrated.

Comparison chart
A chart sets out the pros and cons of the various threads.

CHAPTER 2: Projects (pages 34–126)

Projects start with beginner braids. Once you have mastered the basic moves, you can move to any project in the book.

You will need
Dimensions of thread are listed, along with findings, and bead quantities when required. Kumihimo threads are shown as sections and lengths, as they are sold in ropes containing four sections. Other threads are shown as lengths.

Skill level
Projects are graded by skill level from one to three; one is for beginners and three is for accomplished braiders.

Disk format
Shows which format of disk to use.

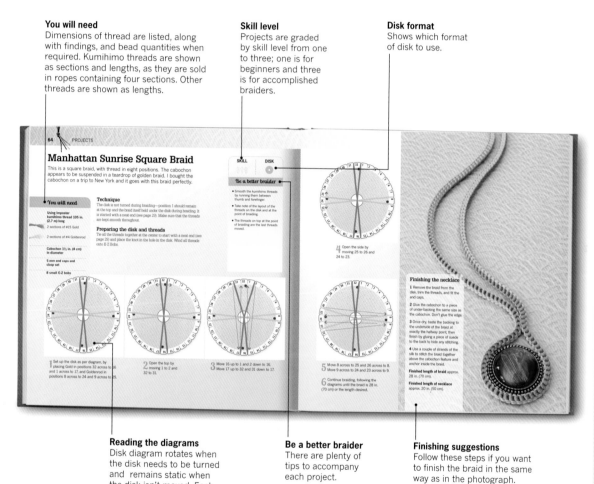

Reading the diagrams
Disk diagram rotates when the disk needs to be turned and remains static when the disk isn't moved. Each diagram shows the position of the threads before the move is made; red arrows indicate the direction in which the threads travel.

Be a better braider
There are plenty of tips to accompany each project.

Finishing suggestions
Follow these steps if you want to finish the braid in the same way as in the photograph.

Thread notes

Imposter—Where possible, the projects use Imposter kumihimo thread from Japan. You can substitute other Japanese kumihimo threads in synthetic silk (Biron), fine silk, or premium silk— 105-in. (2.7-m) lengths. Alternatives: 2 mm satin cord or #1 pearl cotton.

Exotic Lights—silk embroidery thread by Colourstreams in Australia— 8¾-yd. (8-m) skeins. You can substitute #3 pearl cotton or 1 mm satin cord.

Templates

Turn to the last page for kumihimo templates that you can use to make your own cardstock disks.

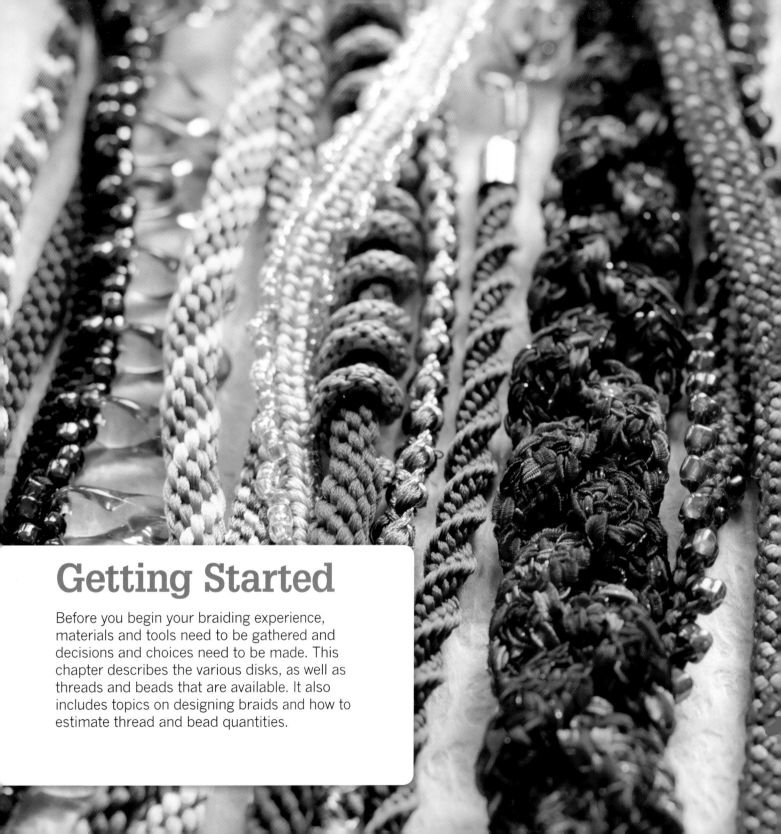

Getting Started

Before you begin your braiding experience, materials and tools need to be gathered and decisions and choices need to be made. This chapter describes the various disks, as well as threads and beads that are available. It also includes topics on designing braids and how to estimate thread and bead quantities.

Kumihimo Disks

The kumihimo disk has been designed to bring Japanese braiding to crafters of all ages and levels of experience. Because it is lightweight, it is easy to hold. The disks are also inexpensive and hard wearing.

Japanese braiding is traditionally done on a wooden stand called a marudai. The modern, portable, and user-friendly version is the kumihimo disk or loom, available in various shapes and sizes.

The slots hold the threads gently and firmly in place, providing the tension and avoiding the need for weights. Keep a separate disk for very fine work and another for materials that might damage the slots, such as wire.

The hole in the center of the disk dictates the thickness of the finished braid. A hole that's 1 in. (2.5 cm) in diameter will suit braids just under 1 in. (2.5 cm) thick.

Cardstock disks are an inexpensive way to start the braiding experience, and the disk included with this book is a great way to begin.

When choosing a disk, consider the type and number of threads to be used. There should be more slots than the number of threads. To make a 16-thread braid, use the 32-slot disk so that the threads can change position easily. Generally speaking, foam disks such as the original Hamanaka disk are best for silk and specialty kumihimo threads. The slots should be cleanly cut so that they don't catch the threads.

Disk sizes

The size of the disk has little influence on the end result—the number of slots is the deciding factor. The most common round disks are 6 in. (15 cm) in diameter with 32 slots. Smaller-sized disks usually have fewer slots, restricting the size and thickness of braid that can be made. A typical Round 8 braid will fit on a smaller disk with 16 slots—however, a Round 16 braid will need the extra slots for the threads to move in and out of.

A typical disk

A typical disk is made from ⅜ in. (1 cm) thick high-density foam and is very durable compared with cardboard disks. The most common is the Hamanaka round disk, 6 in. (15 cm) in diameter, and made of high-density foam. The disk has 32 slots, with the numbers to the right of the slot. The hole in the center is for the braid to come through. The round disk is used to make a range of braid shapes including round, square, and flat braids. It also has four dots representing north, south, east, and west. Several braids start with a thread on either side of these dots.

Disk shapes

The different shapes of disks available are round, square, and octagonal. The round disk is used for round, square, flat, spiral, and hollow braids. The square disk has 24 numbered slots and eight lettered slots and is used for making very flat braids. Both round and square disks are used to create the projects featured in this book. Beaded braids can be worked on either shape. The octagonal disks make little or no difference to the end result.

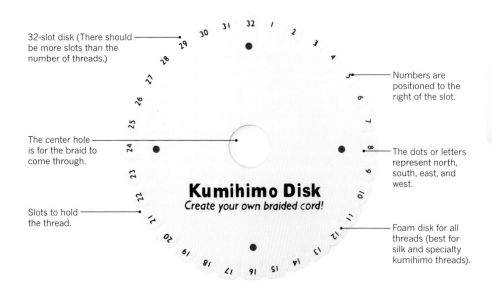

32-slot disk (There should be more slots than the number of threads.)

The center hole is for the braid to come through.

Slots to hold the thread.

Kumihimo Disk
Create your own braided cord!

Numbers are positioned to the right of the slot.

The dots or letters represent north, south, east, and west.

Foam disk for all threads (best for silk and specialty kumihimo threads).

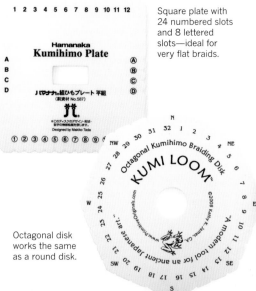

Square plate with 24 numbered slots and 8 lettered slots—ideal for very flat braids.

Hamanaka
Kumihimo Plate

Octagonal disk works the same as a round disk.

Findings

The choices of end caps and clasps available are many and varied, from base metal to precious metal. Don't spoil your creation by using inferior findings that may tarnish.

End cap and clasp sets (1)
End caps and clasp sets specifically designed in Japan for kumihimo are of superior quality and are very easy to use. Because they come as an assembled set, all the braider has to do is glue them onto the ends of the completed braid. Available in gold or silver colortones and in sizes 5 mm, 8 mm, and 10 mm, they come with a ball-and-socket clasp already attached.

Bead caps or cones (2)
Bead caps or cones are a great alternative to the standard end caps. These are usually more decorative and provide scope for very fancy finishes to your braid. There is a huge selection available.

Magnetic end cap (3)
Fancy sets of magnetic end caps are also available in a base metal in gold and silver colors. The sizes range from 5 mm to 6.5 mm. They are ideal for something inexpensive yet decorative.

Ends for flat braids (4)
Deluxe crimp ends designed specifically for flat braids are available in several color finishes and sizes. They are perfect for finishing a flat braid. They usually come as individual components that need assembly, giving the braider the opportunity to use their choice of clasp. They can be tricky to use, particularly for beginners. They have fold-over ends with little teeth to grip the braid. Apply a small amount of glue to the braid before folding the cap in place with a pair of pliers.

Self-assembled end caps (5)
Another way of buying end caps is to purchase the individual components and assemble them yourself. There is a huge selection available in a range of sizes and colors. This gives you the freedom to select the particular type of clasp for the project.

Clasps (6)
Choose the clasp style best suited to the project—for example, lobster, toggle, or fancy. The advantage of fancy clasps is that they can become a feature rather than a practical way of finishing the project.

Other findings
Some of the projects use key-ring ends or phone ends. To make these, take apart a set of ends and attach the appropriate fitting to complete.

Tools and materials

No doubt you'll have tools such as scissors, tape measures, and needles available. And if you are a beader, you'll have beading tools and equipment. In addition, you will need the following:

Bobbins
The best bobbins for kumihimo are the plastic E-Z Bobs. These are a neat way of keeping threads tidy and tangle free, and also for preventing beads from sliding off the thread. An essential accessory for braiders of all skill levels, they are available in small (1⅞ in./4.5 cm), medium (2½ in./6 cm), and large (3½ in./9 cm) sizes. The small ones are stackable, which is useful when they are not in use. I recommend using E-Z Bobs for lengths of thread over 1 yd. (1 m).

Strong thread for whipping
Whipping thread won't be seen once it's glued into the end cap, but using the wrong type of thread can result in the braids coming undone before you get the end caps on. Hand-quilting thread is ideal, because it is cotton-coated polyester. You could also use strong beading thread, such as Nymo.

Glue
Some craft glues won't hold the thread inside the metal end, and some don't dry clear. If you can't get the recommended glues, and are in any doubt, test first. E6000 or Helmar Premium Craft Glue work well and are readily available.

Beading board or mat
A straight board allows beads to be easily sorted and picked up with a beading needle.

Beading tools
General tools like round-nose, flat-nose, and chain-nose pliers, a bead scoop, and thread cutters can be useful for beaded braids, opening and closing jump rings, and assembling bead caps.

Beading and large-eye needles
There are several brands, sizes, and types of beading needles available, and if you are a beader you'll have your favorite. For a large-eye needle, I love the bent-tip ones; however, any metal large-eye needle is fine. This could be used for threading beads with very large holes.

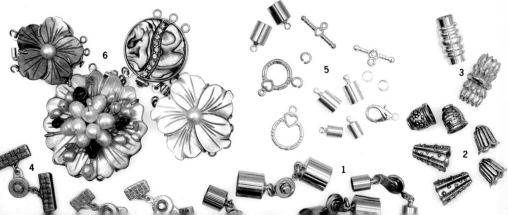

Threads

Japanese braiding or kumihimo can be made with just about any type of thread or fiber. There are, however, some guidelines that will be useful for the beginner.

Tip

For something really different, try braiding with paper cord, parachute cord, wire, or plastic tubing. The possibilities are endless.

The more common threads used for kumihimo are the traditional kumihimo threads available in silk, synthetic, and metallic, so there is a thread type available to suit every budget. These threads come pre-cut, ready to go on the disk, making them very easy to use.

Other threads commonly used are silk embroidery flosses, pearl (sometimes called perlé) cotton embroidery floss, rat tail (satin cord), and ribbons. Plain yarns, fluffy yarns, and mixtures provide amazing textures. All of these threads have to be cut to the correct length, or the skein divided into the number required for the particular project.

Most of the projects in this book use kumihimo threads. These are available in ropes of four sections and are suitable for braiders of all levels. Each section has 39 individual threads that the more experienced braider can separate to make very fine braids. These are readily available worldwide. The choice of colors is amazing, too.

Exotic Lights silk thread by Colourstreams is also used for some of the projects. It is a high-luster, gentle-twist, single-ply thread equivalent to pearl cotton #3. If you are substituting a different brand of silk, make sure it is the equivalent pearl cotton #3. Exotic Lights and Ophir are Australian products, but are available online.

To work out the approximate thickness and appearance of a finished Round 8 braid, twist together eight of the selected threads. If it's too fine, consider doubling the number of threads, and vice versa if it's too thick. If the colors aren't quite right, alter your selection. There is no right or wrong way to assemble the threads. It all depends on the look you want and the threads you have available.

Try mixing different types of thread. A Round 8 braid has thread in eight positions, but there is nothing to say that they all have to be the same type of thread. You could, in fact, have eight different threads if that gives the look you want to achieve.

The samples below show some of the textures that can be achieved by simply changing the thread type. These are just a few of the types of thread that can be used for Japanese braiding. Other threads that are textured in their own right could also be used, as in Frou Frou Braided Necklace on page 72.

Working with kumihimo thread

Kumihimo thread comes in ropes containing four sections, each of approximately 39 individual threads. The length of these threads is 105 in. (2.7 m). Because there are four sections, all you have to do for an 8-warp braid is place them across the disk in the starting position, tie them at the center, and away you go.

When handling these, make sure they are kept smooth and there are no knots or kinks in any of the fine threads. Smooth the sections by running them through your thumb and index finger, similar to smoothing hair for a ponytail. You may have to repeat this process several times. Be patient and work slowly.

Should you wish to separate the sections to use fewer threads, gently ease the number of threads required. Make sure you have good light, and pull the threads laterally from each other. If you pull them along their length, you run a bigger risk of tangles.

Should the threads start to tangle, stop, and gently pull them back along the length, smoothing as you go, and start again. If they continue to tangle, pull one thread at a time (this is where the good light comes in).

If you wish to cut the sections in half, tie a knot in both ends *before you cut*. Always use E-Z Bobs with this thread.

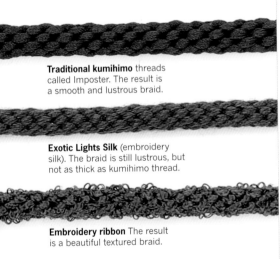

Traditional kumihimo threads called Imposter. The result is a smooth and lustrous braid.

Exotic Lights Silk (embroidery silk). The braid is still lustrous, but not as thick as kumihimo thread.

Embroidery ribbon The result is a beautiful textured braid.

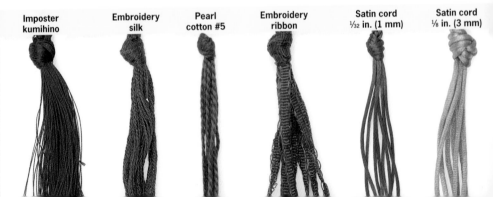

| Imposter kumihimo | Embroidery silk | Pearl cotton #5 | Embroidery ribbon | Satin cord 1/32 in. (1 mm) | Satin cord 1/8 in. (3 mm) |

The chart below uses a Round 8 braid as a guide (see page 36), since it is the easiest and most common kumihimo braid. Approximate diameters are given for the same braid made with different threads.

To make a thicker braid with the same threads, either double the threads in each position or make a Round 16 braid where there will be threads in 16 positions (see page 42). To make a finer braid with the same threads, use half the threads in each position or make a Round 4 braid where there will be threads in only four positions on the disk (see page 46).

Thread Chart for a Round 8 Braid

TYPE OF THREAD	PROS	CONS	STRANDS PER SLOT	APPROX. FINISHED DIAMETER
Kumihimo threads	Goes straight onto disk as is	Care needed if separating into individual threads	39	³⁄₁₆ in. (5 mm)
Metallic kumihimo thread	Can go straight onto disk as is or be mixed with plainer threads	Care needed if separating into individual threads	39	¼ in. (6 mm)
Fine silk (Ophir)	Can be cut into eight easily and is ideal for threading beads	Only makes fine braids	1	⅛ in. (3 mm)
Thicker silk (Exotic Lights)	Can be cut into eight easily and has a lustrous sheen	Only comes in 8¾-yd. (8-m) skeins	1	⅛ in. (3 mm)
Pearl cotton #5	Inexpensive and readily available	Lack of luster—needs to be used double	1	⅛ in. (3 mm)
Pearl cotton #3	Inexpensive and readily available	Lack of luster—slightly uneven result	1	⅛ in. (3 mm)
Silk embroidery floss/8 strand	Lustrous sheen and readily available	Only makes fine braids	8	⅛ in. (3 mm)
Embroidery ribbon ⅛ in. (3 mm)	Makes a fine-textured braid	Not suitable for smooth braids	1	⅛ in. (3 mm)
Satin cord ¹⁄₃₂ in. (1 mm)	Quick and inexpensive	Makes a firm braid	1	³⁄₁₆ in. (5 mm)
Satin cord ⅛ in. (3 mm)	Quick to braid with	Makes a very firm braid—uses far more thread	1	⅜ in. (10 mm)

Beads

Beads of any type, size, and shape can be incorporated into kumihimo to enhance the appearance of the braids.

The best advice regarding bead selection is to always choose the best-quality bead available within your budget, regardless of the type of bead. When deciding on the beads to incorporate in the braid, consider the way in which the beads will be used. They could be threaded on the actual braiding threads or cord before you begin, or sewn on later. Often the size of the hole in the bead dictates this.

The most popular, readily available, and economical beads to use are Japanese seed beads. The holes are usually quite large, so they are easy to thread onto the chosen braiding thread. Other small beads that work really well with kumihimo are the various shapes of Czech glass bead.

The use of lampwork beads, crystals, and pearls gives a new meaning to the concept of beaded braids. They can be used for a uniform appearance or to make truly unique free-form braids. Strings of pearls, semiprecious chips, and the smallest seed beads can be braided by using the actual strings to make an all-bead braid. The beads would have to be rethreaded on longer lengths of braiding cord to do this.

Other ways to dress up a braid include adding a beaded cabochon or pendant, or simply sewing on some bugle beads.

Types of beads

Any shape of bead can be incorporated into kumihimo. The choice is limited only by your imagination. If you're new to braiding, start with plain, round seed beads and work your way through all the categories described here.

Japanese seed beads (1)

The sizes are uniform and the holes are larger and cut more cleanly than other seed beads. The uniform shapes play an important role in the finished appearance, as the coverage is more even, particularly when used for an all-bead braid.

Kumihimo lends itself to using any of the huge variety of beads that are classed as seed beads. This category includes round, triangular, drop, and magatama beads.

Czech glass beads (2)

The shapes in this category include paddle beads, petals, daggers, and Rizo beads. They give a more dimensional appearance and can be mixed with other beads or used alone. Because the holes are usually quite small, it is best to use a fine thread such as braiding cord or silk.

Lampwork beads (3)

A multitude of bead types fall under this category. These are larger beads available in various shapes and sizes. The hole is usually fairly large, making the beads easy to thread on any type of braiding cord. Use them to give a uniform appearance, or mix them up as in the free-form braids in the project section (see pages 114–123). Use the best-quality beads available within your budget or preferably handmade by a local bead artisan, as in the Blossom Braided Necklace on page 110.

Pearls (4)

Pearls are perfect for any kumihimo braid. These come in some quite unusual shapes, and are usually sold in 16-in. (40-cm) strands. They can be used individually, one at a time, or as strands as in Pearly Pink Twist on page 98. The holes in

Ways to incorporate beads

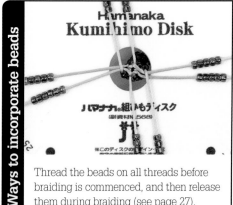

Thread the beads on all threads before braiding is commenced, and then release them during braiding (see page 27).

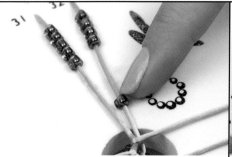

Thread the beads on some threads in advance and release as you come to them (see page 27).

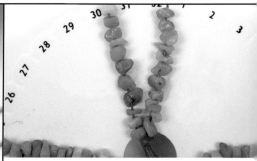

Braid with strings of beads.

pearls are very small, so thread them on fine braiding cord or silk.

Semiprecious beads (5)
Beads that fall into this category are hematite, aventurine, and rose quartz. These are usually either round beads or chips. The chips can be used strung, whereas the round ones are ideal for one-at-a-time release into the braid.

Pendants (6)
The choice of pendants is mind blowing. Make sure the bail of the pendant will fit over the finished braid. To do this, use the scrap piece of thread at the start of the braid to thread through the bail and ease the pendant onto the braid.

Crystals
Mix these with other beads or use alone. Either way, the result is very pleasing. Crystals go particularly well with pearls.

Beaded cabochons
This is a lovely way to combine the two mediums of braiding and beading—the beaded cabochons can then be used as a pendant feature. Alternatively, make a very fine braid to wrap around the stone.

Thread for beaded braids
Whichever thread you choose, the thread for the beaded strands will need to be approximately three times the finished length of the braid, to allow for the amount of thread each bead uses. The thread must go through the hole comfortably without the bead rubbing it and causing it to fray.

- Use the same thread as for the rest of the braid, particularly if the thread is to be visible.
- Use a braiding cord such as C-Lon if the thread won't show.
- Use a beading thread such as Nymo or hand-quilting thread.
- Use very fine silk embroidery cord.

Sew the beads on the finished braid or add a pendant.

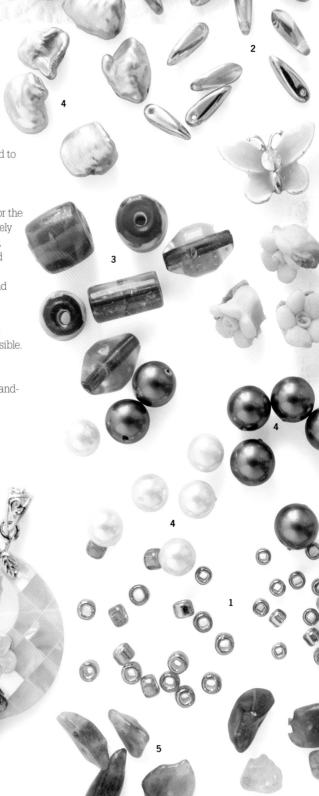

Figuring Thread and Bead Quantities

There are some simple calculations you can use to work out how much thread and how many beads you need to work a specific braid.

Estimating thread quantities

As a general rule, to calculate the amount of thread needed for a 24-in. (60-cm) necklace worked as a Round 8 braid, the length of thread at each position on the disk needs to be double the length = 48 in. (120 cm). Multiply this figure by the number of thread positions or bobbins (8 for a Round 8 braid) = 32 ft. (9.75 m) in total.

Round 8 braid thread quantity = (finished length x 2) x number of thread positions/bobbins.

If possible, always cut threads longer than required and braid right to the end of the thread. A skein of thread 15 ft. (5 m) long, for example, could just be cut into eight even lengths, rather than 8 x 20 in. (50 cm) and wasting the extra 3 ft. (1 m) of thread. Any excess braid can be cut off and used for a small project or sample, or making the project that little bit longer.

Using ropes of kumihimo thread

Kumihimo threads come in a rope of four sections 105 in. (2.7 m) long. Set up the disk to start with a neat end (see page 29) and each position will have thread 52½ in. (133 cm) long. Divide that measurement by two and the expected length of a finished Round 8 braid will be up to approximately 26 in. (66 cm), making this perfect for our 24-in. (60-cm) sample braid.

To make a longer necklace using this thread and pattern, start with eight sections tied together with an overhand knot (see page 22). In this case, each position will need the full 105-in. (2.7-m) length. This will make a Round 8 braid up to 52½ in. (133 cm) long. Use this method if you want the project to have tassels.

A note about tension

The great thing about using the foam disks is that the slots provide the tension and there is no need for weights. In the case of basic round braids where the disk is held during braiding, the braid needs to be retensioned by gently stretching it to its full length. The difference can be seen in the examples opposite below. For most other braids and for the square plate, the braid itself is held under the disk and acts like a counterweight, so there is virtually no extra length to be gained by stretching it.

Estimating bead quantities

The best way to calculate quantities of beads for a particular project is to work 1 in. (2.5 cm) with the selected beads and pattern, then calculate from there. If you don't already have the beads or beads of a similar size to make a test braid and you're not following a project sheet, work from the table at right. If you have used 20 beads in 1 in. (2.5 cm) of braid, the calculation for a 24-in. (60-cm) necklace will be:

20 beads x 24 in. (60 cm) = 480 beads.

This calculation will work for most types of beads and will apply to all braiding patterns.

Simple Round 8 braid in two colors, with four threads in color A and four in color B. If the finished necklace is to be 24 in. (60 cm), then the amount of thread required will be four 48-in. (120-cm) lengths for color A, and four 48-in. (120-cm) lengths for color B.

Intricate Round 12 braid, same two colors, using the same thread. Six threads are color A, and six are color B. This time, for a 24-in. (60-cm) necklace the amount of thread will be six 48-in. (120-cm) lengths for color A, and six 48-in. (120-cm) lengths for color B.

Very intricate Round 16 braid, same two colors, using the same thread. Eight threads are color A, and eight are color B. A 24-in. (60-cm) necklace will need eight 48-in. (120-cm) lengths of color A, and eight 48-in. (120-cm) lengths of color B.

Making a test braid is also a good way to check that you are happy with the result.

Another way to calculate bead quantities is to thread ten beads onto each beaded thread, see what length of braid you get, and calculate from there. So if there are eight threads each with ten beads making a 4-in. (10-cm) braid, the calculation for a 24-in. (60-cm) necklace will be:

8 threads x 10 beads = 80 beads ÷ 4 in. (10 cm) x 24 in. (60 cm) = 480 beads divided evenly across eight threads.

What these calculations don't tell you is the weight you'll need. There are many factors that come into play with seed beads. The numbers vary with the brand, the finish, and the quality of the beads. In the panel at right is a very rough guide. Based on this guide, the 24-in. (60-cm) necklace made with size 6 beads would need approximately 40 g = 480 beads. Or in size 8 beads, approximately 12 g = 480 beads.

For strings of beads, design the braid to accommodate the beads. This could mean making the beaded section first, as in the Beadazzled Free-form Necklace on page 114.

HOW MANY BEADS TO BUY			
Approx. weight of beads for a 20 in. (50 cm) Round 8 necklace.			
Size of bead	Beads per gram	Beads per 1 in. (2.5 cm) of braid	Approximate weight to buy
11	110	68	1360 beads = 15 g
8	40	56	1120 beads = 30 g
6	12–16	40	800 beads = 50 g

Other factors influencing the calculation

The amount of thread required depends on several factors, including the type and thickness of thread, the braiding pattern, and the technique used for the start and finish. The thinner the thread, the longer the braid will be. The more complex the braid, the more thread will be used. Starting and finishing with tassels and loops will also require more thread.

For more complex and beaded braids, allow two-and-a-half to three times the length, multiplied by the number of positions.

Tip
Regardless of the type of bead, always allow extra to avoid running out.

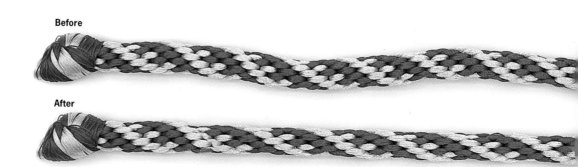

Before

After

Before and after examples of tension Sample at top is a Round 12 braid taken straight off the disk. Sample at bottom shows the same braid after stretching it to its full length. This will give the finished length of a braid. Note how much more uniform the braid structure is.

Designing Braids

The first thing to decide is what to make. Next, visualize how the project will look, and the materials, colors, and pattern of braid needed to achieve the result.

Only when the above decisions are made can the braiding begin. In other words, the braiding is the last step in designing braids. So take time to select the right ingredients for the project.

Deciding what to make is probably the easiest part, and here we will look at designing a necklace. Decisions to be made to achieve this are:

● The color and type of thread (see page 12).
● The finished length.
● What braiding pattern will best achieve your vision.
● If it's to be a beaded or non-beaded necklace; if beads are to be included in the design, you'll need to decide upon the color and type of bead.
● How complex a braid is required. Will the beads work just as well with a simpler braid?
● How the piece will work, or how you will start and end the piece. Do you want to use metal findings, in which case the braid can be started with a neat end, or perhaps start and end with tassels?

Necklace and bracelet lengths

There are numerous standard necklace and bracelet lengths, which may be helpful when planning your design.

Measuring for a bracelet:

The wrist plus 1 in. (2.5 cm) = finished length. The length to braid is the finished length minus the assembled clasp.

Patterns or braid structure

Things to consider when choosing the braiding pattern to be used are:

■ What is my vision of the finished piece?
■ What materials will be used to achieve this?
■ How intricate does the pattern need to be?
● What is the hero of the piece? The beads, threads, or pattern?

Once these decisions are made, you can select the kumihimo pattern. The simplest Round 8 braid can be the best choice when using fancy threads or beads. For plain luscious silks, the braiding pattern can be more intricate as the detail of the braid structure becomes the focus.

The more thread positions there are, the more complex the pattern can be, as seen in samples B and C. Sample D still uses two colors, but the structure is quite intricate. To achieve this, the thickness of the threads used is quite different. The red threads are double the thickness of the same thread in the other sample, and the metallic threads are only a quarter of those used before.

Color

Things to consider when choosing the colors for your project:

● What is my vision of the finished piece?
● How will the colors work?
● In what proportions will they be used?

When choosing more than one color, consider how the colors will work with each other. Are they in harmony or contrast? If you think of a plant that has green leaves and purple flowers, the colors are opposite each other in the color wheel and therefore form a contrast

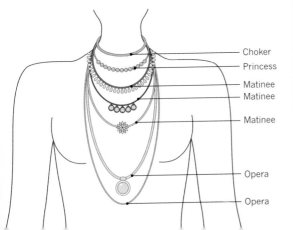

This diagram shows the different lengths on a bust.

Choker
Princess
Matinee
Matinee
Matinee
Opera
Opera

STANDARD NECKLACE LENGTHS		
	Choker	16 in. (40 cm)
	Princess	18 in. (45 cm)
	Matinee	20 in. (50 cm)
	Matinee	22 in. (55 cm)
	Matinee	24 in. (60 cm)
	Opera	30 in. (75 cm)
	Opera	36 in. (90 cm)
STANDARD BRACELET SIZES	Small	6½ in. (16 cm)
	Average	7 in. (18 cm)
	Large	7½–8 in. (19–20 cm)

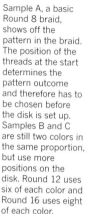

(complementary). Colors that contrast can be seen in Stained Glass Window Collar on page 66. The only way for the colors of the window to shine through is to use contrasting colors or colors from various colorways. However, they are held together with one dominant color—in this case, the purple.

The colors of red/orange/yellow fall leaves harmonize with each other, as the colors are beside each other on the color wheel (analogous). A perfect analogous braided example is the Manhattan Sunrise Square Braid on page 64, where the colors blend together to form a golden hue. Another way for colors to harmonize is to use two shades of one color (monochrome). For example, the Turquoise Sky Lariat on page 50 uses two shades of the one color to show off the braid structure.

The proportion of each color is also important. To highlight the structure of the braid, two colors of equal proportion work best. To show a pattern within the braid, use as many colors as are necessary to display the pattern. The Round 16 Series of braids on page 44 are perfect examples of how proportions of color are necessary to see the design. For example, with the Diamond pattern, the outline of the diamond is in one color and the background in another—in our sample, there is the same number of threads for each color.

If the center thread is changed to be the same color as the diamond outline, you'll have a solid diamond shape using nine threads and the background will now only have seven, making the total of sixteen threads. If the center is to be a different color altogether—say, gold—there will be one thread of gold, eight for the diamond outline, and seven for the background, still making the total of sixteen threads.

The number of colors affects the pattern outcome when making the same braid. Experiment with the color layouts. To work out

Sample A, a basic Round 8 braid, shows off the pattern in the braid. The position of the threads at the start determines the pattern outcome and therefore has to be chosen before the disk is set up. Samples B and C are still two colors in the same proportion, but use more positions on the disk. Round 12 uses six of each color and Round 16 uses eight of each color.

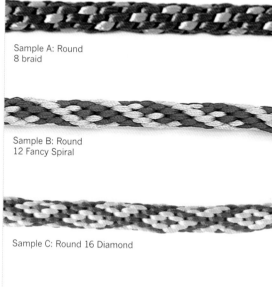

Sample A: Round 8 braid

Sample B: Round 12 Fancy Spiral

Sample C: Round 16 Diamond

The structure of the braid is influenced by the proportion of colors used.

Heart and Diamond use the same number of positions for each of two colors.

Flame is more detailed, but the proportions of the colors are quite different to make the little flame show up.

Tree has more detail, so requires more colors in the same number of positions.

where the colors go when setting up the disk, follow the instructions in the project section, and then experiment with changing them around to see what the result will be. If you like the result, keep a record of the layout.

Beads

There are many beads available, and the types and sizes are covered in more detail on page 14.

Things to consider when choosing beads for your project:
- What is my vision of the finished piece?
- How will the beads work?
- What type of bead is required?
- What color of bead is needed?
- What part of the braid is to be beaded?
- How many beads are required?

Once these decisions have been made,

consideration should be given to the type of thread the beads are to be threaded on. If the piece has beads on all the threads, like the Golden Rhapsody Necklace on page 84, then braiding cord—C-Lon or similar—is fine, as the cord won't show.

If the piece is to have beads on only some of the threads, like the Ocean Blue Flat Beaded Neckpiece on page 104, then the beads will

The Color Wheel

Choosing the color can take longer than making the project, so use this color wheel to help make the choice easier.

Complementary colors are located directly opposite each other on the color wheel. These colors create designs that will stand out. To soften the contrast, use the analogous colors on either side of them.

Analogous colors are those found next to each other on the color wheel. These colors harmonize with each other. Use a neutral color to tie them together.

Monochromatic color schemes use different shades of the same color. Make sure there is sufficient difference in the shades to be visible.

- **Luscious silk:** If the thread you have chosen is a luscious silk or a very fancy thread, the braid will be best done in one color to show off the beautiful threads. Often, a plain Round 8 braid works best.

- **Patterned braids** and those with different structures lend themselves to using more than one color to show off the detail of the braid design. The colors can harmonize, complement, or contrast with each other.

- **Metallic beads or thread** will add richness and depth to the color scheme of the project.

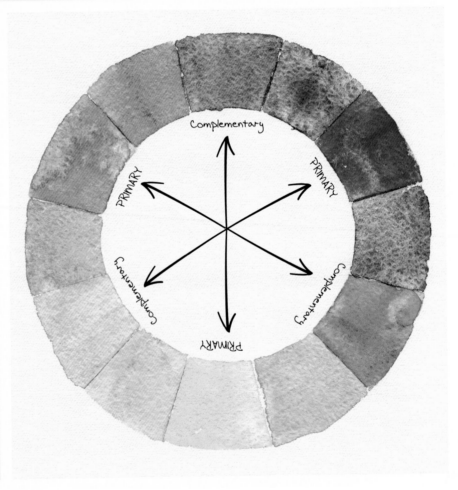

need to be threaded on the same silk or thread used for the rest of the braid.

To check how the beads will work and the number of beads needed to achieve a successful outcome, use the formulas in "Figuring Thread and Bead Quantities" on page 16.

To check how the beads will work and the number of beads needed to achieve a successful outcome, use the formulas in "Figuring Thread and Bead Quantities" on page 16.

Things to make with braids

- **Jewelry**, including necklaces, bracelets, earrings, and brooches.
- **Scissor keepers**—braid straight onto the scissor handle or use a loop or finding, and finish with a tassel (see page 32).
- **Bag tags/ties** to use as identification or decorative strap for a camera or smart phone (see page 74).
- **Key rings**, either with a finding or a loop. A great way to use up any excess braids.
- **Belts**—either braided or tied using macramé techniques.
- **Curtain ties** made with several braids braided together. Flat braids are best.
- **Shoelaces**—use fine braids to make fun shoelaces in the team colors.
- **Bag handles**—especially beautiful for handmade felted or crocheted bags.
- **Lanyards** for reading glasses and sunglasses.
- **Decorative knots or frogging** for handmade clothing or furnishings.
- **Decorations**—wind a really long braid around a foam shape—a bell, for example— for holiday decorations. A 2-in (50-mm) foam bell uses approx. 2½ yd (2.25 m) of a fine Round 8 braid.
- **Bowls or plant holders**—wind a really long braid into a bowl shape or around a pot.

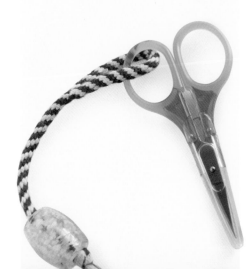

Beads are only on two of the eight threads and all the threads are visible. If you used a different type of thread, it would show and possibly distort the braid.

Basic Techniques

The following techniques will assist you in making the most of your braiding experience and will become a reference tool as you progress with making beautiful Japanese braids. In this section, a Round 8 braid, which has thread in eight positions, has been used as an example.

Setting up the disk

The disk has 32 slots to hold the threads during braiding and a hole in the center through which the braid emerges underneath the disk. The setup for a Round 8 braid is shown here, but the principle is the same for all patterns.

Take the kumihimo round disk and eight lengths of thread tied together at one end with an overhand knot. Place the knot in the center hole of the disk—cardstock or foam—and slot the threads into the starting positions as shown (right).

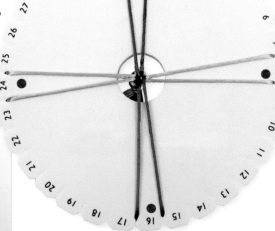

Using the round kumihimo disk

The same techniques apply to both foam disks and cardstock disks; however, foam disks are easier to hold, more durable, and the threads stay in the correct position at the point of braiding (see step 3, below). It is good practice to keep a disk for very fine braids and another one for thick braids or wire, as these may damage the slots. Note that the slot numbers on the disk are to the right of each slot.

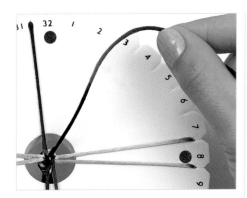

1 Hold the disk in your left hand, keeping your right hand free to move the braiding threads—vice versa if you are left handed. Using your right hand, lift the threads out of the slot, as close to the disk as possible.

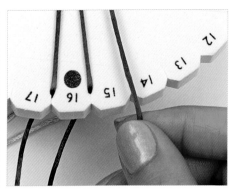

2 Place the thread in the destination slot, keeping the thread taut.

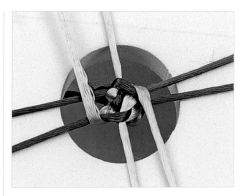

3 The point at which the threads cross at the hole in the disk is called the point of braiding. The braid should remain in the middle of the hole and not off to one side. If this happens, the braid will be deformed.

Correcting a deformed braid

Adjust or reposition the threads to pull the point of braiding back into the center.

Try holding the disk with your left thumb over the top left thread as you move the right thread. If there is still any wobble, hold the braid itself under the disk.

Regardless of the type of disk or braiding pattern being used, hold the tie or knot under the disk for the first few moves. Once the braid is established, hold the disk for round braids, and the braid itself for other patterns. This will help to prevent the braid from becoming deformed.

MADE A MISTAKE?
Simply reverse the moves one at a time back to the mistake, correct it, and continue in the right direction. Follow the diagrams in reverse—it will make the process easier.

Braids where disk is not turned

The disk is not turned during braiding for braids such as flat, square, and spiral. For these braids, the braid itself is held with the left thumb and index finger, under the disk at the point of braiding. The disk rests on the left fist, leaving the right hand free to make the moves. The patterns for these braids are designed for the right hand to flow easily to the next thread to be moved. Get to know what the point of braiding looks like for each particular braid.

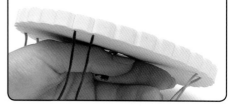

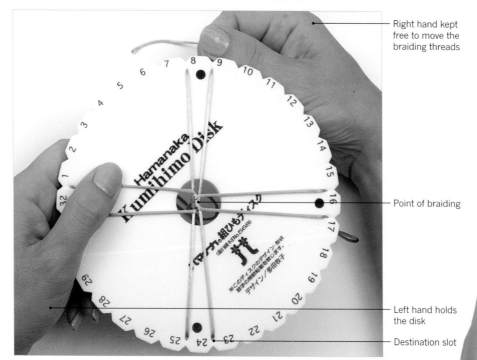

Right hand kept free to move the braiding threads

Point of braiding

Left hand holds the disk

Destination slot

Turning the disk

For round braids that require the disk to be turned during braiding, it doesn't matter which way you turn the disk, but it must be in the same direction for the whole braid. In the featured projects, the disk is turned counterclockwise. The right hand will flow easily to the next pair of threads, ready for the next move.

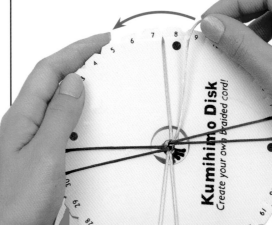

Using the square plate

The square plate has numbered slots at the top and numbers in circles at the bottom, and it's held as shown below. The braid itself is held under the square plate at the point of braiding, leaving the right hand free to make the moves. The disk is not turned during braiding.

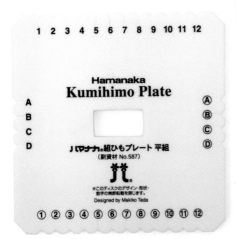

1 Place the knot or tie of the threads through the hole and hold it under the plate with your left hand, so that the plate rests on your fist. Your right hand will be free to arrange the threads in their starting positions. Make sure that the threads are held firmly in the slots and lie flat against the plate.

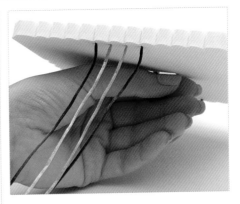

2 Hold the tie or braid under the plate at the point of braiding with your left thumb and index finger, leaving your right hand free to make the moves. The plate will sit on the left fist throughout.

3 Lift the threads out of the slot, as close to the underside of the plate as possible.

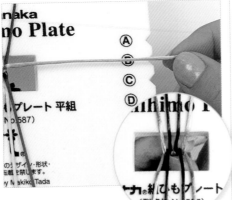

4 Place the thread in the destination slot, still keeping close to the plate. The point of braiding should remain in the middle of the hole in the plate.

STOPPING AND STARTING ON THE SQUARE DISK

Complete the entire sequence of moves. When you return, start from the first move.

Using E-Z Bobs

E-Z Bobs are used to keep your working threads tangle free (see page 11). Open the E-Z Bob, wind the thread smoothly and evenly around the center, and lock it in place by closing the bobbin. Wind the bobbins so that they hang just under the disk. For beaded braids, don't have the beads too tight on the thread. Allow room for the beads to move.

Stopping and starting

Have to leave your braiding part way through? No problem! For Round 8, 12, and 16 braids only, there are two ways of leaving them so that you know exactly where you are when you return. This only relates to the round braids.

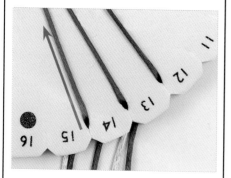

1 Leave three threads at the bottom of the disk—after a "right comes" (see page 36). When the disk is picked up, the next move will be a "left goes"—the bottom left-hand thread moves to the top of the disk.

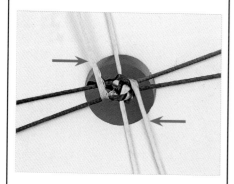

2 Take note of which threads are on top at the point of braiding. These were the last threads moved. In this case, green is on top so the next threads to be moved will be purple.

Functional knots and leader thread

There are three everyday knots that are very useful in Japanese braiding. The overhand and lark's head knots can be used to start or finish your braids (see below and page 26), so it is worth learning the techniques. The reef or square knot is used when making a leader thread.

Overhand knot

This is a basic knot for tying the threads together at one end, or as a temporary knot to tie the braid at the end prior to finishing with end caps or a tassel. This is the easiest way to start and finish a braid.

1 Preparing to tie the threads together with an overhand knot. Take the short end of threads and loop them over the length as shown.

2 Pass the short end through the back of the loop just formed.

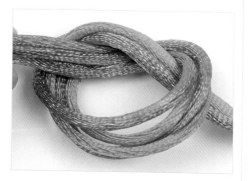

3 Tighten the knot as close to the short end of the threads as required for the particular project.

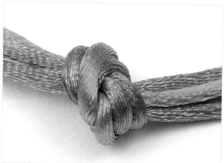

4 The finished overhand knot. **Tip:** If the knot is to be discarded, don't worry too much about the wrap of the colors. If it's to be on show, take care with the wrap of the colors and the threads in the knot.

Using a leader thread

A leader thread is used to thread beads onto cord or braiding thread that won't otherwise fit through the eye of a needle and then through the bead. Note: Hand-quilting thread is perfect for this.

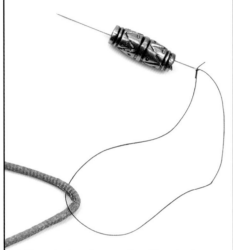

1 Thread a beading needle with a short length of strong beading thread and knot it with a reef knot (see right). The knot should be to the side of the leader away from the needle and where the braiding cord will be.

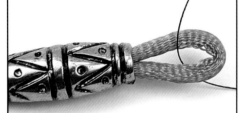

2 Pick up the beads with the needle, and slide them over the leader thread and onto the braiding thread.

Reef or square knot

This is a strong, flat knot that is ideal for joining beading thread and when making a leader thread (see left).

1 Pass the right-hand thread over the left, and then the left-hand thread over the right.

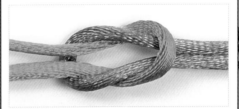

2 Pull each pair of threads to tighten the knot.

3 This knot is also often used in beading when two lengths of beading thread need to be joined. If necessary, it can also be used to join really fine braiding cord or thread where a bead will cover the join, or the join can be worked into the braid.

Lark's head knot

This is used to tie the middle of the threads together to give a neat end that can go straight into an end cap when the braid is finished. Whether the threads are tied with a lark's head knot before placing on the disk, or tied once the disk is set up, it will still give what's known as a neat end start.

1 This photo shows the lark's head—black thread—looped around the midpoint of four lengths of braiding thread. Pull the tails of the black thread to tighten the knot.

2 Once the knot is tightened, the ties go into the hole in the disk. This technique is used in many of the projects in this book.

Beaded braids

Select the braiding cord or thread to match the beads and set up the disk in the starting position for your chosen braid.

- Sort the beads into equal groups, one for each thread that is to have beads. For a Round 8 braid with beads on every thread, you'll need eight groups of beads. For a braid where only two of the threads have beads, you will only need two groups of beads.
- Using a leader thread or large-eye needle, thread the beads onto the braiding cord or thread. Wind the threads onto E-Z Bobs as you go to prevent the beads from falling off.

Threading beads on braiding thread
Use either a beading needle with a leader thread attached (see opposite), or a large-eye beading needle to loop the braiding cord or thread. Pick up the beads with the needle, and slide them over the leader thread and onto the braiding cord. Wind the threads onto E-Z Bobs as you go.

Things to watch out for
- The beads must be on the outside of the braid and as close as possible to the braid. Check this regularly. If a bead goes inside the braid, undo the braid back to the culprit, correct, and continue braiding in the right direction.
- Start and finish fully beaded braids with a section approximately ½ in. (1 cm) without beads. These will be whipped around, trimmed, and fitted inside the end caps.

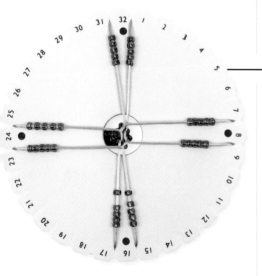

Releasing the beads

1 Slide five or ten beads of each beaded thread up on top of the disk ready to be incorporated in the braid. As well as making the disk easier to handle, it also allows you to keep a check on the beads used, because when the first thread runs out of beads, all other beaded threads should only have one bead left.

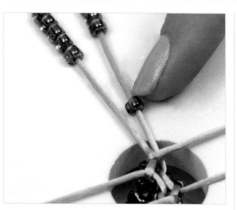

2 Slide the bead down against the braid, and then make the braiding move.

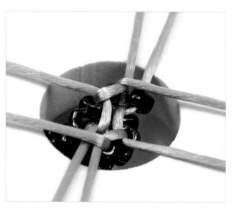

3 The bead should remain in place tucked under the thread being crossed over. Hold the bead in place under the disk with your left thumb and index fingernails when starting a beaded section. If necessary, or you find it easier, do this throughout.

Starting and Finishing

There are several ways to start and finish a braid to give it a professional look, and this is determined before braiding commences.

You need to decide how the final braid is to be used and how it will work before the disk is set up. For example, making a Round 8 braid into a 24-in. (60-cm) necklace with end caps and clasp can be started with a neat end, whereas the same necklace of 30 in. (75 cm), to be finished with tassels, will start with an overhand knot to be made into the tassel at the finish.

Braids starting with an overhand knot

This technique could be used for braids with lots of colors or odd numbers of colors, or if the braid is to have tassels. It is also used if the threads are of a particular length and a longer braid is required—for example, when using kumihimo threads that are 105 in. (2.7 m) long and the finished length of the project is more than about 24 in. (60 cm). This start will allow the finished braid to be up to approximately 48 in. (120 cm). Refer to "Figuring Thread and Bead Quantities" on page 16.

Starting and finishing with an overhand knot

The easiest way to start and finish a braid is with an overhand knot (see page 25).

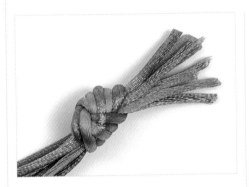

1 To start the braid, tie all of the braiding threads together at one end.

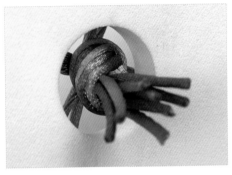

2 Place the knot in the hole of the disk, and spread the threads around the disk in the chosen starting position. Keep hold of the knot for the first few moves.

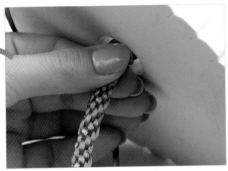

3 When the braid is finished, remove the threads from the slots and hold the braid firmly under the disk at the finish point.

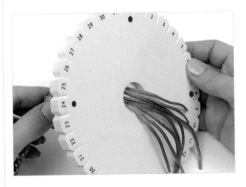

4 Remove the braid from the disk and tie the threads together, as in step 1.

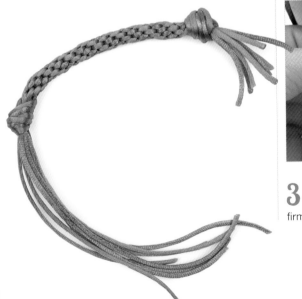

Starting with a neat end

This is another very easy way to start a braid, making the end perfect for fitting straight into an end cap. The tie is removed before gluing the end cap in place. Where possible, this particular way of starting braids has been used for the projects in this book.

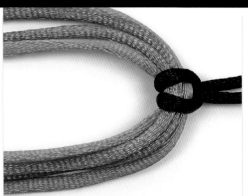

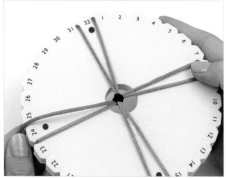

1 Take all the lengths of braiding thread and fold in half. Using a scrap thread approx. 6 in. (15 cm) long, tie together with a lark's head knot (see page 26). Note that there are only four lengths to make a Round 8 braid.

2 Place the knot in the hole of the disk and, keeping hold of it, place the threads in the slots so that they lie flat against the top of the disk. Keep hold of the tie underneath the disk for the first few moves of the braid. Once the braid is established, hold the disk as for round braids (see page 22), or as per the instructions.

Finishing with a connector bead

Any type of bead can be used as a connector bead as long as it has a hole large enough and is long enough for both ends of the braid to go into. Check the bead size as described for end caps. This is a good way to finish a bangle or a piece of jewelry that doesn't need to open.

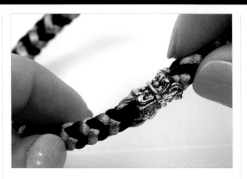

1 Assuming that the braid was started with a neat end, remove the tie, apply some glue, and insert the braid into the bead so that it only goes in halfway.

2 Whip around the finish end of the braid (see page 30), trim, apply some glue, and fit into the other side of the bead. Push the two ends of the braid so that they come together inside the bead.

Finishing with end caps

This is a very quick way to give your braid a professional finish.

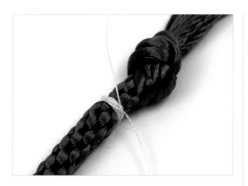

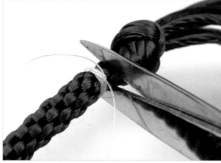

1 Remove the braid from the disk and tie with a length of strong thread—hand-quilting thread works well. Whip this thread around the braid several times to secure the braiding threads. If you prefer, the braid can be tied off with an overhand knot and the whipping done around the braid, leaving a small gap before the knot, and then trimmed.

2 Trim the excess threads and knot around ⅛ in. (3 mm) from the end of the braid. Don't cut the braid too near the thread as it may ravel.

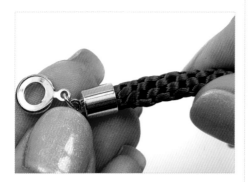

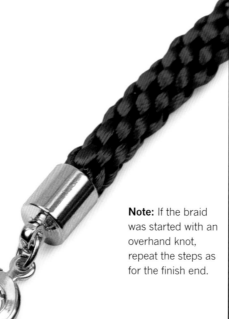

3 Apply some clear craft glue to the cut end, and using a twisting motion, insert into an end cap. At the start end, discard the thread tie, apply the glue, and insert into the other end cap. Set the braid aside for the glue to dry.

Note: If the braid was started with an overhand knot, repeat the steps as for the finish end.

Starting with a braided loop

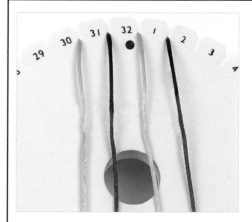

1 Place the braiding threads on the disk with the midpoint across the hole. Fix the threads into positions at the top: 30, 31, 32, and 1 on the round disk or the middle positions at the top of the square disk.

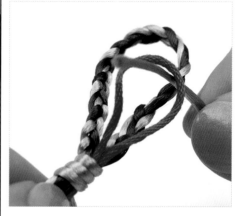

5 Tuck the tail of the whipping thread into the loop of the scrap piece.

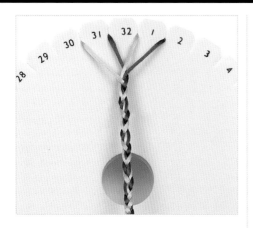

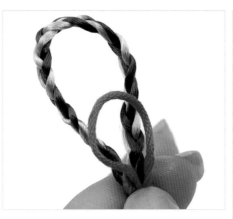

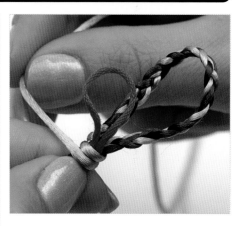

2 Braid a length approximately 3 in. (7.5 cm) long so that the midpoint is across the hole of the disk. To make a three-element braid, some of the threads will need to be grouped and treated as one. **Tip:** Hold the disk with your knees so that your hands are free to braid.

3 Fold the braid in half and remove it from the disk. Lay a loop of scrap thread approximately 8 in. (20 cm) long on top of the braid, as shown with the red loop.

4 Using one of the braiding threads from the back of the braid (turquoise), whip around the braided loop and loop thread while holding it all firmly.

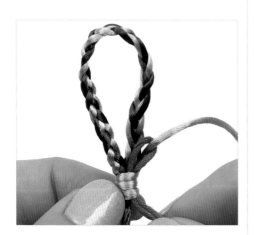

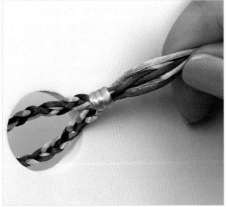

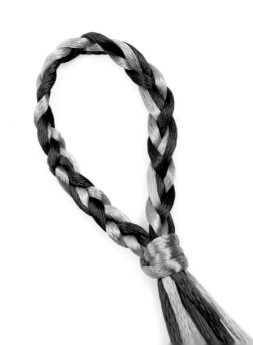

6 Pull the two tails of the scrap piece so it pulls the turquoise thread through the whipping. Discard the scrap piece.

7 To set up the disk, place the braided loop in the hole of the disk and the threads in the starting position.
Note: When setting up the disk and for the first few moves, be sure to hold the loop at the whipping to prevent it from collapsing.

Finishing with a tassel

Making a tassel is a beautiful way to finish a kumihimo braid. It can be used with bookmarks as in the Chevron Bookmark (see page 76), bag pulls, key rings, or jewelry as in A Braid for Jasmine (see page 78), and can become the real feature of the project.

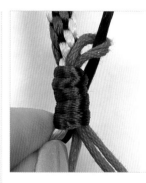

1 Remove the braid from the disk, being sure to keep a firm hold on the finish point of the braid. Lay a loop of scrap thread approximately 8 in. (20 cm) long on top of the braid, as shown with the red loop.

2 Select one of the braiding threads from the back of the braid (purple), and whip around the base of the braid and the loop thread several times while holding it all firmly. The whipping should be done in the direction of the braid—that is, up the braid.

3 Tuck the tail of the whipping thread into the loop of the scrap piece.

4 Pull the two tails of the scrap piece so that it pulls the purple thread through the whipping. Discard the scrap piece. Steam the tassel and trim the threads to the length required.

Finishing with a beaded tassel

The addition of beads to the tassel gives another dimension to the project. In the Sweet Georgia Beaded Lariat (see page 94), the thread is completely covered with beads, while the Luscious Beaded Lariat (see below, and page 124) still has the braiding threads showing.

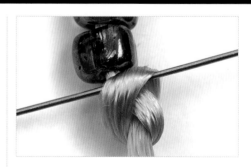

1 Make a tassel as above, but don't trim it until all the beads have been added. Using a beading needle and leader thread, slide the required number of beads onto the threads of the tassel.

2 Once each thread is beaded, tie off with an overhand knot. Do this around a pin, so that you can slide it right up against the last bead. Repeat this process on as many of the threads as required. Steam and trim the tassel.

Finishing with a double overhand knot

A double overhand knot is a beautiful and practical way to finish very fine braids.

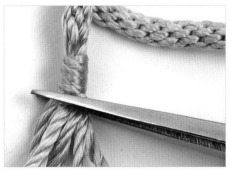

1 Whip around the finish end of the braid (see page 30). The thread used for this whipping will need to be fairly long, as it will be used to stitch the end into the knot. This is normally done with strong sewing thread—I have used a thread from the braid for visibility.

2 Trim the braiding threads as close as possible to the whipping, being careful not to cut the whipping.

3 Create your double overhand knot by making a loop in the braid.

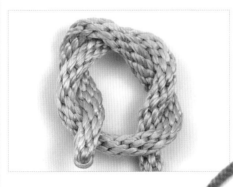

6 Thread the ends of the whipping thread onto a needle, and secure in place by sewing the whipping threads back into the knot and anchoring them inside the braid. When all is secure, trim the whipping threads so that they can't be seen.

4 Take the end of the braid through the loop twice.

5 Tighten the knot by easing or rolling it up to the end of the braid to make a little ball.

A ⅛ in. (3 mm) braid started with a braided loop and finished with a double overhand knot

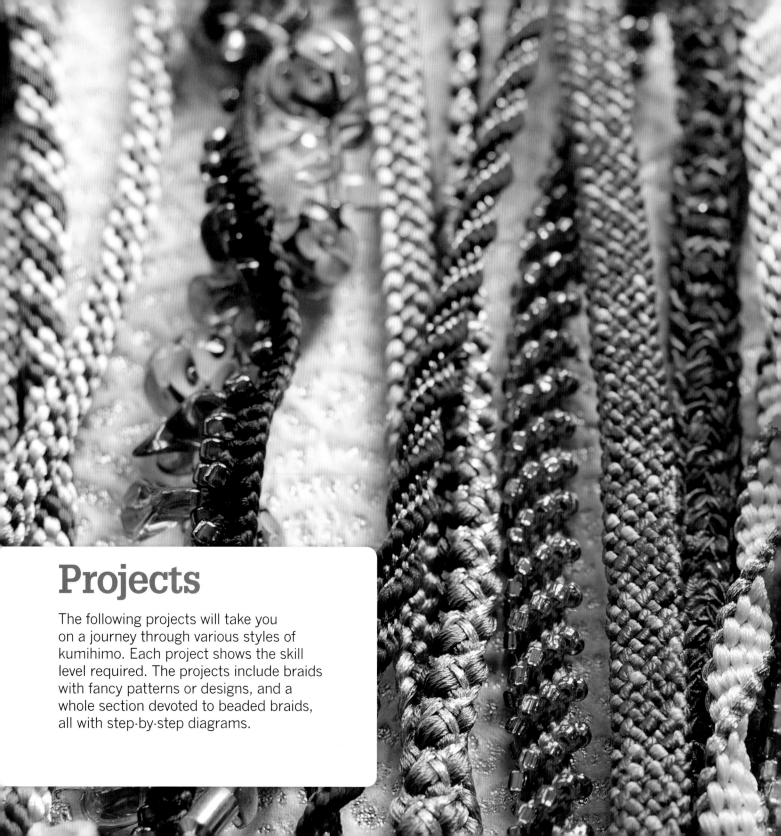

Projects

The following projects will take you
on a journey through various styles of
kumihimo. Each project shows the skill
level required. The projects include braids
with fancy patterns or designs, and a
whole section devoted to beaded braids,
all with step-by-step diagrams.

My First Kumihimo Braid

Your first kumihimo braid is a Round 8 braid, which is quick and easy to make. The more advanced braider can use this versatile braid to show off the beautiful colors and textures of threads available. Master this braid and the possibilities are endless, as you'll see with the fabulous projects in this book.

SKILL	DISK

Be a better braider

- Once the initial moves have been done, forget about the numbers—just make the moves and follow the chant "Right comes, left goes," always turning the disk counterclockwise to the next pair of threads.

- When putting the disk down, leave three threads at the bottom of the disk ready to start with a "left goes."

- The threads at the point of braiding should remain in the center of the hole.

- For every move there is a counter move. If a thread is moved from top to bottom, another thread goes from bottom to top.

You will need

Using 3 ft. (1 m) lengths of 4-ply crochet cotton

2 sections of Light Blue

2 sections of Dark Blue

1 bead with a large hole

Technique

This is called a Round 8 braid because there are eight threads on the disk and the braid has a solid round structure. The right thread comes toward you during each move, and the left goes away. The disk is turned counterclockwise during braiding.

Preparing the disk and threads

Using a scrap piece of thread, tie the mid point of the four lengths of thread together with a lark's head knot (see page 26). Note how the threads cross over the hole in the disk. This is called the point of braiding. For the first few moves, keep hold of the tie to prevent the threads from slipping. Once the braid is established, you only need to hold the disk itself. Position the tie over the hole in the disk, with the ends going through to the underside of the disk.

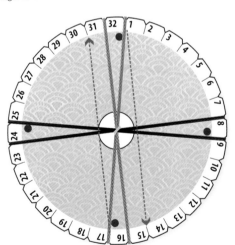

1 Set up the disk as per diagram, by placing Light Blue in positions 32 across to 16 and 1 across to 17, and Dark Blue in positions 8 across to 24 and 9 across to 25.

2 Move 1 down to 15 and 17 up to 31. Right comes down toward you, left goes up away from you. Turn the disk counterclockwise to the next pair of threads.

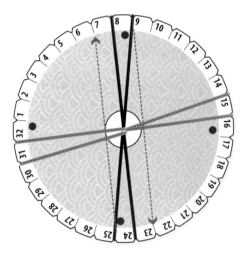

3 Move 9 down to 23 and 25 up to 7. Right comes down toward you, left goes up away from you. Turn the disk counterclockwise to the next pair of threads.

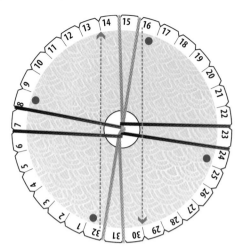

4 Move 16 down to 30 and 32 up to 14. Right comes, left goes. Turn the disk counterclockwise to the next pair of threads.

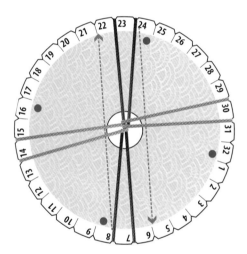

5 Move 24 down to 6 and 8 up to 22. Right comes, left goes. Turn the disk counterclockwise to the next pair of threads.

6 Continue braiding, following the diagrams. As you braid, the threads will move around the disk and a spiral pattern will appear. Braid until you run out of thread or reach the length required. Congratulations—you've made your first kumihimo braid.

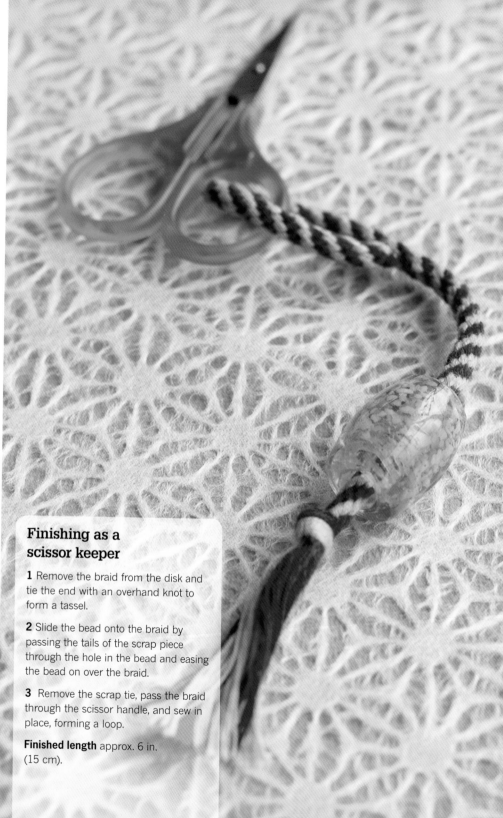

Finishing as a scissor keeper

1 Remove the braid from the disk and tie the end with an overhand knot to form a tassel.

2 Slide the bead onto the braid by passing the tails of the scrap piece through the hole in the bead and easing the bead on over the braid.

3 Remove the scrap tie, pass the braid through the scissor handle, and sew in place, forming a loop.

Finished length approx. 6 in. (15 cm).

My First Series of Kumihimo Braids

Here you will see how changing the color setup can completely change the end result of the same braid. Make these individual necklaces on the round kumihimo disk, using kumihimo thread for a luxurious result, or create a selection of key rings or zipper pulls by attaching different findings to the braids.

SKILL	DISK

Be a better braider

- A rope of kumihimo thread has 4 sections of thread 105 in. (2.7 m) in length. See section on threads on page 12.

- An alternative thread would be satin cord or rat tail. This would overcome the problem of cutting kumihimo thread.

You will need

Using Imposter kumihimo thread 105 in (2.7 m) long

- **Double Zigzag:** 2 sections of #12 Pale Orchid and 2 sections of #25 Cool Red

- **Vertical Stripe:** 2 sections of #12 Pale Orchid and 2 sections of #47 Berry

- **Single Zigzag:** 2½ sections of #12 Pale Orchid and 1½ sections of #25 Cool Red

- **Dot:** 1 section of #12 Pale Orchid and 3 sections of #47 Berry

1 x 5 mm end cap and clasp set for each necklace

8 small E-Z-Bobs

Finished length
approx. 24 in. (60 cm).

Technique

The braids shown on these pages are all Round 8 braids. The setup for each is shown here, and the moves are detailed on My First Kumihimo Braid (see page 36). The disk is turned counterclockwise during braiding. Braids 1, 2, and 4 are started with a neat end (see page 29). The Single Zigzag is started with an overhand knot because of the odd number of color positions.

Preparing the disk and threads

Tie all the threads together at one end with a knot and place the knot in the hole of the disk. Wind all the threads onto small E-Z Bobs.

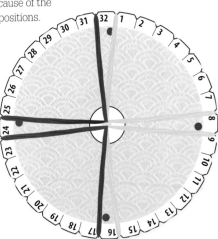

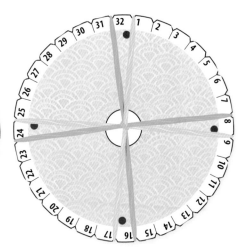

Double Zigzag (1)

1 Using two sections of Orchid and two sections of Red, set up the disk as follows: Orchid in positions 1, 8, 9, and 16; Red in positions 17, 24, 25, and 32.

2 Start braiding as per the instructions on pages 36–37. The braid will develop a double zigzag pattern.

3 See page 30 for instructions on how to finish the Double Zigzag with end caps.

Vertical Stripe (2)

1 Using two sections of Orchid and two sections of Berry, set up the disk as follows: Orchid in positions 1, 9, 17, and 25; Berry in positions 32, 8, 16, and 24.

2 Start braiding as per the instructions on pages 36–37. The braid will develop a vertical stripe pattern.

3 See page 30 for instructions on how to finish the Vertical Stripe with end caps.

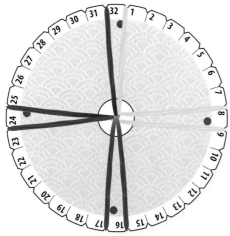

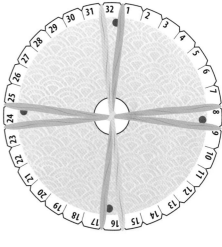

Single Zigzag (3)

1 Cut the whole sections of thread in half to give three lengths of Orchid and five lengths of Red. Note: Before cutting, knot each end of the section so that it will remain together once cut. This only applies if using kumihimo threads (see page 12).

2 Tie the three lengths of Orchid and five lengths of Red together at one end with an overhand knot. Place the knot in the hole and set up the disk as follows: Orchid in positions 1, 8, and 9; Red in positions 16, 17, 24, 25, and 32. The knots at the long ends can now safely be undone. Each length will be half that of the other three braids—52½ in. (1.35 m).

3 Start braiding as per the instructions on pages 36–37. The braid will develop a single zigzag pattern.

4 Whip this braid at the starting end and remove the overhand knot before fitting the end cap.

Dot (4)

1 Using one section of Orchid and three sections of Berry, set up the disk as follows: Orchid at positions 32 and 16; Berry at positions 1, 8, 9, 17, 24, and 25.

2 Start braiding as per the instructions on pages 36–37. The braid will develop a dot pattern.

3 See page 30 for instructions on how to finish the Dot with end caps.

Sunset Spiral Necklace

This is a Round 12 braid, with threads in twelve positions. By using different colors, a spiral pattern is formed. The braid is thicker and slightly shorter than a Round 8 braid made with the same materials, and the spiral pattern is longer.

SKILL	DISK

Be a better braider

- Take note of the layout of the threads. The pairs of colors will remain opposite each other throughout.

- When putting the disk down, leave three threads at the bottom so that, when you return, you start with a "left goes."

- An alternative thread to use would be satin cord or rat tail.

You will need

Using Imposter kumihimo thread 105 in (2.7 m) long

2 sections of #4 Goldenrod

2 sections of #50 Orange

2 sections of #15 Gold

6 mm end caps and clasp set

12 small E-Z Bobs

Technique

This is an easy braid to do, as it is similar to a Round 8 braid (see page 36) and is started with a neat end. In the same way, the right thread comes toward you during each move, and the left goes away. The disk is turned counterclockwise during braiding.

Preparing the disk and threads

Tie the six lengths of thread together at the center to start with a neat end (see page 29). Place the tie in the hole in the disk and position the threads as instructed. Wind all the threads onto small E-Z Bobs. Hold the tie for the first few moves (see page 36).

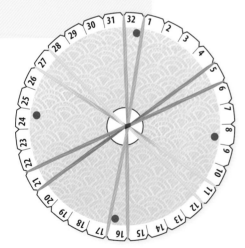

1 Set up the disk as per diagram, by placing Gold in positions 1 across to 17 and 32 across to 16, Orange in positions 5 across to 21 and 6 across to 22, and Goldenrod in positions 11 across to 27 and 12 across to 28.

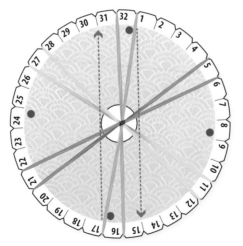

2 Move 1 down to 15 and then 17 up to 31. Turn the disk counterclockwise to the next pair of threads.

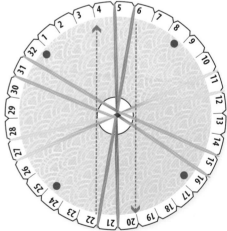

3 Move 6 down to 20 and then 22 up to 4. Turn the disk counterclockwise to the next pair of threads.

Finishing the necklace

See page 30 for instructions on how to finish the braid as a necklace with end caps.

See page 30 for instructions on how to finish the braid as a necklace with end caps.

Finished length approx. 22 in. (55 cm).

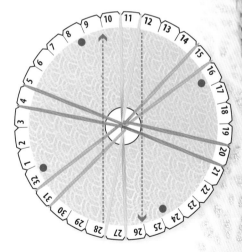

4 Move 12 down to 26 and 28 up to 10. Turn the disk counterclockwise to the next pair of threads.

5 Continue braiding, following the diagrams until the braid is the length required.

Rose Trellis Necklace

This is a Round 16 braid, with threads in sixteen positions. By using different color setups, you can make braids with a variety of patterns. This particular setup has a spiral of Brick working its way through the Jade, and a dot of Pink representing the rosebuds. Finish with decorative knots as shown, or a tassel (see page 32).

SKILL	DISK

Be a better braider

- Take note of the layout of the threads and how they look at the point of braiding.

- An alternative thread to use would be rat tail.

- Wonder what the next move should be? Look at the point of braiding to work it out—whichever thread is on top of the other threads was the last thread moved.

You will need

Using Imposter kumihimo thread 105 in (2.7 m) long

1 section of #16 Pink

4 sections of #34 Brick

11 sections of #30 Ocean Jade

8 mm end caps and clasp set

16 small E-Z Bobs

Technique

The Round 16 moves are the same as for a Round 8 braid (see page 36) and Round 12 braid (see page 40), only with more threads. Because there is just one position for the Pink thread, the braid will be started by tying all the threads together with an overhand knot. The disk is turned counterclockwise during braiding.

Preparing the disk and threads

Tie all the threads together at one end with an overhand knot and place the knot in the hole of the disk. Wind all the threads onto small E-Z Bobs.

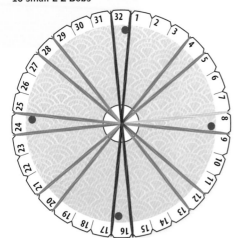

1 Set up the disk as per diagram, by placing Brick in positions 32, 1, 16, and 17, Pink in position 8, and Jade in positions 4, 5, 9, 12, 13, 20, 21, 24, 25, 28, and 29. **Note:** There are two spaces between each pair of threads.

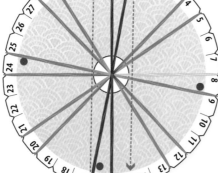

2 Move 1 down to 15 and 17 up to 31. Turn the disk counterclockwise to the next pair of threads.

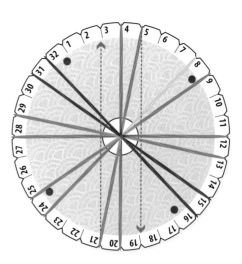

3 Move 5 down to 19 and 21 up to 3. Turn the disk counterclockwise to the next pair of threads.

Finishing the necklace

1 Remove the braid from the disk and, using a strong beading thread, whip around both ends of the braid to secure (see page 30).

2 Fashion into your choice of decorative knots (a flat button knot is shown here).

3 Trim all excess threads, apply some craft glue, and insert each end into an end cap (see page 30).

Option Finish with a tassel at each end (see page 32) and wear as a lariat or belt.

Finished length of braid approx. 50 in. (127 cm).

Finished length of necklace approx. 22 in. (55 cm).

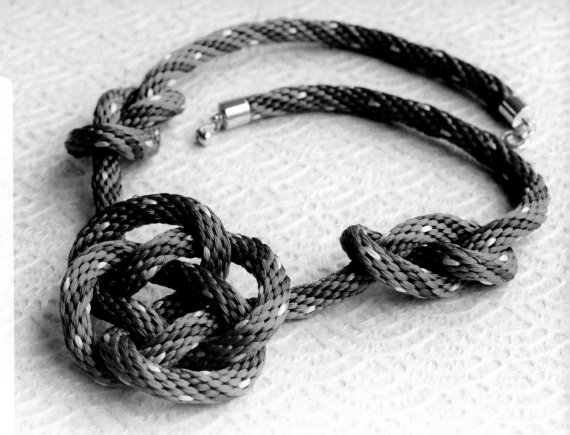

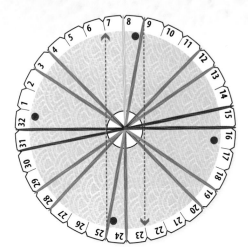

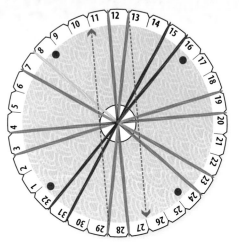

4 Move 9 down to 23 and 25 up to 7. Turn the disk counterclockwise to the next pair of threads.

5 Move 13 down to 27 and 29 up to 11. Turn the disk counterclockwise to the next pair of threads.

6 Continue braiding, following the diagrams until the braid is the length required. **Note:** When Brick is back in position 1 and the sequence is ready to begin again, all the threads should be in their starting positions.

Round 16 Series

These pages show some of the Round 16 braids that can be made using various color layouts. The technique is the same as for the Rose Trellis Necklace (see page 42).

(see page 42)

SKILL	DISK

Be a better braider

For really quick and easy braids, substitute the thread with rat tail or pearl cotton #3. Start each braid with 18-in. (45-cm) lengths tied together with an overhand knot toward one end. This could become the tassel to make it really quick and easy. If you use this method, there is no need to use E-Z Bobs.

You will need

Using Imposter kumihimo thread 105 in. (2.7 m) long

- **Heart:** 8 sections of #16 Pink and 8 sections of #25 Cool Red

- **Diamond:** 8 sections of #16 Pink and 8 sections of #25 Cool Red

- **Flame:** 3 sections of #16 Pink, 1 section of #25 Cool Red, 5 sections of #47 Berry, and 7 sections of #41 Warm Silver

- **Tree:** 1 section of #16 Pink, 2 sections of #25 Cool Red, 5 sections of #47 Berry, and 8 sections of #41 Warm Silver

- **Christmas Tree:** 1 section of #15 Gold, 2 sections of #25 Cool Red, 5 sections of #2 Emerald, and 8 sections of #41 Warm Silver

16 small E-Z Bobs

- **For necklaces:** 4 x 8 mm end caps and clasp sets

- **For key rings:** 4 x 8 mm end caps with key ring fittings attached

Technique

Refer to the Rose Trellis Necklace (see page 42) for technique and braiding instructions. The disk is turned counterclockwise during braiding.

Preparing the disk and threads

Tie all the threads together at one end with an overhand knot and place the knot in the hole of the disk. Wind all threads onto small E-Z Bobs.

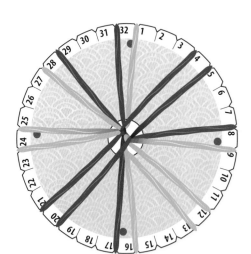

Heart (1)

1 Set up the disk as per diagram, by placing Pink in positions 1, 9, 12, 13, 16, 24, 25, and 28, and Red in positions 32, 4, 5, 8, 17, 20, 21, and 29.

2 Follow braiding instructions as for the Rose Trellis Necklace (see page 42).

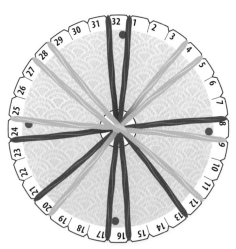

Diamond (2)

1 Set up the disk as per diagram, by placing Pink in positions 4, 5, 9, 12, 20, 25, 28, and 29, and Red in positions 32, 1, 8, 13, 16, 17, 21, and 24.

2 Follow braiding instructions as for the Rose Trellis Necklace (see page 42).

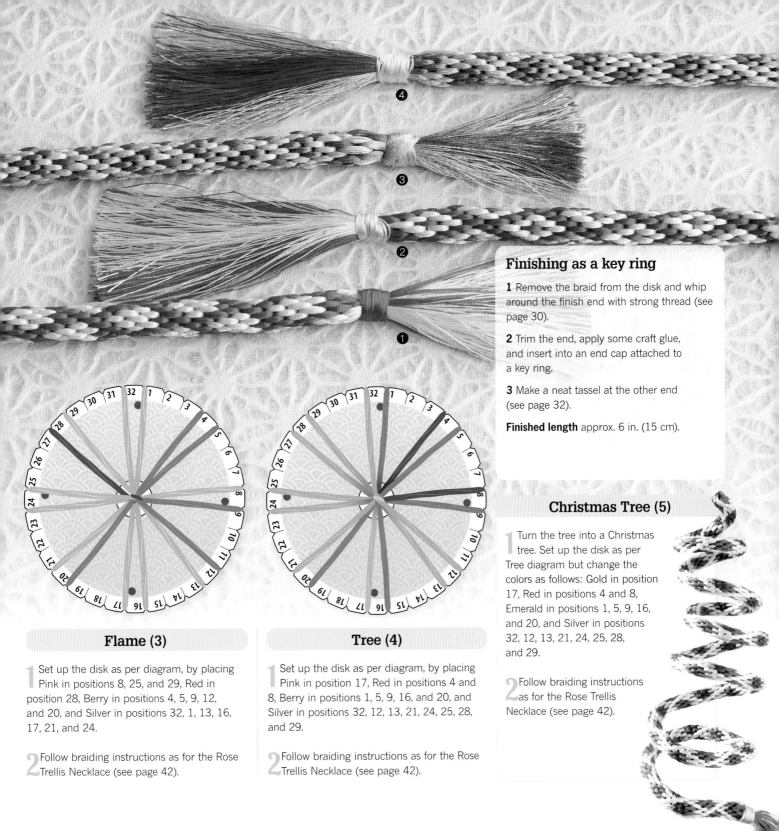

④

③

②

①

Finishing as a key ring

1 Remove the braid from the disk and whip around the finish end with strong thread (see page 30).

2 Trim the end, apply some craft glue, and insert into an end cap attached to a key ring.

3 Make a neat tassel at the other end (see page 32).

Finished length approx. 6 in. (15 cm).

Christmas Tree (5)

1 Turn the tree into a Christmas tree. Set up the disk as per Tree diagram but change the colors as follows: Gold in position 17, Red in positions 4 and 8, Emerald in positions 1, 5, 9, 16, and 20, and Silver in positions 32, 12, 13, 21, 24, 25, 28, and 29.

2 Follow braiding instructions as for the Rose Trellis Necklace (see page 42).

Flame (3)

1 Set up the disk as per diagram, by placing Pink in positions 8, 25, and 29, Red in position 28, Berry in positions 4, 5, 9, 12, and 20, and Silver in positions 32, 1, 13, 16, 17, 21, and 24.

2 Follow braiding instructions as for the Rose Trellis Necklace (see page 42).

Tree (4)

1 Set up the disk as per diagram, by placing Pink in position 17, Red in positions 4 and 8, Berry in positions 1, 5, 9, 16, and 20, and Silver in positions 32, 12, 13, 21, 24, 25, 28, and 29.

2 Follow braiding instructions as for the Rose Trellis Necklace (see page 42).

La Plume Multi-strand Necklace

This braid is perfect to create a subtle, elegant braid for a particular pendant or drop. Divide it into multiple strands if you'd like a thicker braid to support a heavier pendant.

Be a better braider

- Keep hold of the braid itself under the disk throughout.

- Keep 1 in the northern position, to the top of the disk, and keep using the slots at the dots.

- The secret with this braid is to keep the right-hand crossover move above the left-hand thread.

- When the braid is removed from the disk, tie it with an overhand knot to secure before whipping. This knot will be cut off before end caps are fitted.

You will need

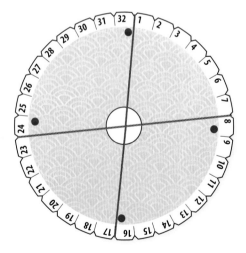

Four 6¹/₂-ft. (2-m) lengths of Exotic Lights #50 Blackberry Ripple silk or pearl cotton #3

5 mm end caps and clasp set

Pendant with a hole of approx. 10 mm

4 small E-Z Bobs

Technique

This is a Round 4 braid, with threads in four positions, and just four moves to create this ⅛-in. (3-mm) braid. The disk is not turned during braiding.

Preparing the disk and threads

Tie all the threads together at one end with an overhand knot and place the knot in the hole in the disk. Wind the threads onto E-Z Bobs.

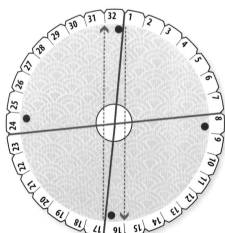

1 Set up the disk as per diagram, by placing threads in positions 1, 8, 17, and 24.

2 Move 1 down to 16 and 17 up to 32.

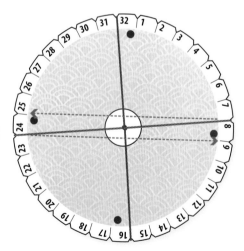

3 Move 8 across to 25 and 24 across to 9.

4 Continue braiding, following the diagrams until the braid is the length required.

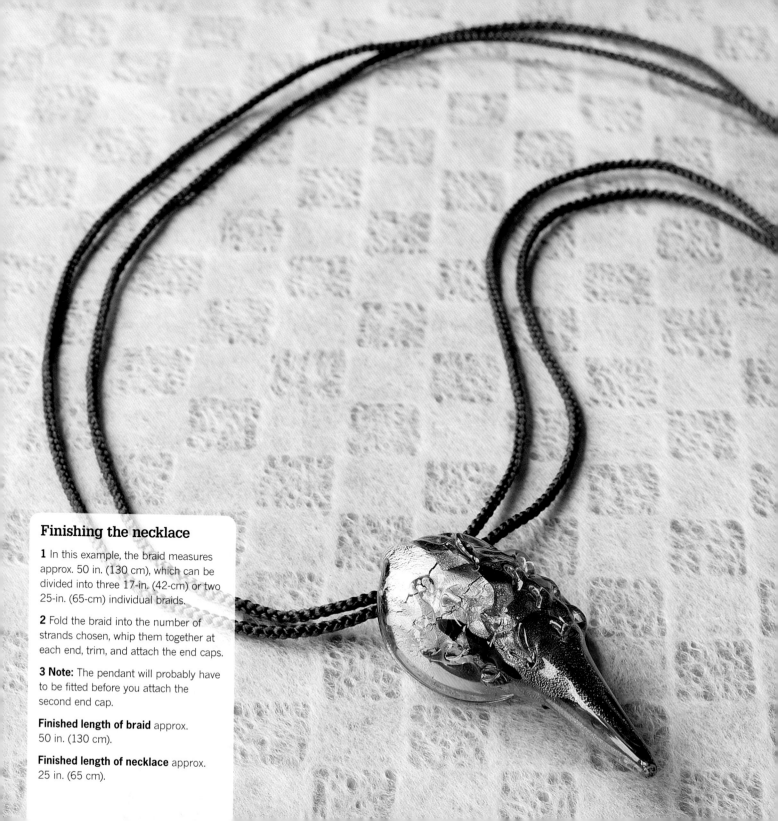

Finishing the necklace

1 In this example, the braid measures approx. 50 in. (130 cm), which can be divided into three 17-in. (42-cm) or two 25-in. (65-cm) individual braids.

2 Fold the braid into the number of strands chosen, whip them together at each end, trim, and attach the end caps.

3 Note: The pendant will probably have to be fitted before you attach the second end cap.

Finished length of braid approx. 50 in. (130 cm).

Finished length of necklace approx. 25 in. (65 cm).

Peacock Ribbon Braid

Make this stunning flat braid using variegated kumihimo ribbon, which gives a wonderful texture. Wear it on its own, attach a pendant, or combine with a beaded bracelet.

Be a better braider

- When making flat braids, hold the braid under the disk and let the disk rest on your hand.
- Always leave the disk at the completion of a round, so that you restart with the first move.
- Try using flat end caps instead of round ones.
- Kumihimo ribbon comes in a rope of four lengths of ribbon, each 105 in. (2.7 m) long. It is already tied at the center, making it very easy to use.

You will need

1 rope (4 lengths) of kumihimo braiding ribbon in Variegated Peacock, 105 in. (2.7 m) long

8 mm end caps and clasp set

8 small E-Z Bobs

Technique

This is a flat braid, with ribbon in eight positions. There are twelve moves to complete the braiding sequence. The braid is held under the disk during braiding. The disk is not turned.

Preparing the disk and threads

Tie the four lengths of ribbon together at the center to start with a neat end (see page 29). Place the tie in the hole of the disk and position the threads as shown in step 1. Wind the threads onto E-Z Bobs. Hold the tie under the disk while setting up the disk and for the first few moves, then hold the braid itself.

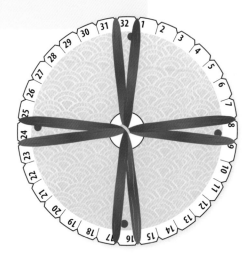

1 Set up the disk as per diagram, by placing the ribbon in position 32 across to 16, 1 across to 17, 8 across to 24, and 9 across to 25.

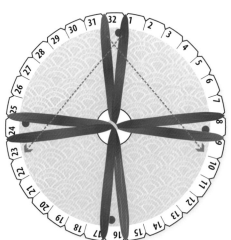

2 Move 32 down to 10 and 1 down to 23.

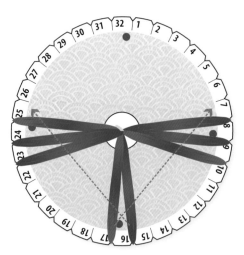

3 Move 16 up to 26 and 17 up to 7.

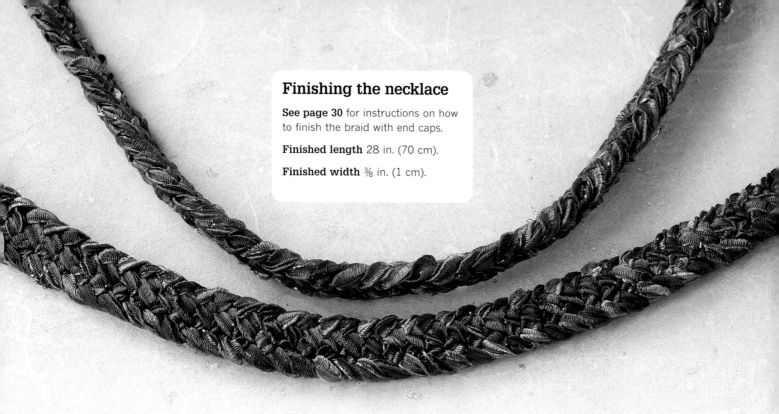

Finishing the necklace

See page 30 for instructions on how to finish the braid with end caps.

Finished length 28 in. (70 cm).

Finished width ⅜ in. (1 cm).

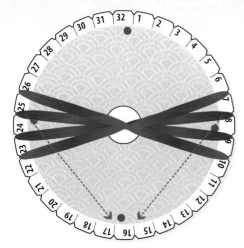

4 Move 8 down to 16 and 25 down to 17.

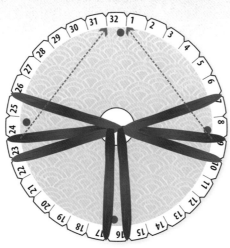

5 Move 9 up to 1 and 24 up to 32.

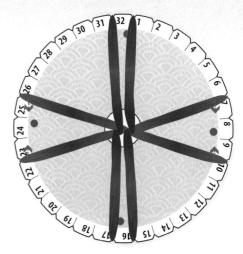

6 Reposition the threads by moving 7 down to 8 and 10 up to 9; then move 26 down to 25 and 23 up to 24. The disk is now ready to start the braiding sequence again.

7 Continue braiding, following the diagrams until the braid is the required length.

Turquoise Sky Lariat

This luscious lariat is made using kumihimo thread in two colors
to show off the pattern in the braid.

 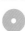
Be a better braider

- When working with kumihimo threads, keep them smooth by running them through your thumb and index finger.

- If you make a mistake, reverse the sequence back to where the error is, correct it, and continue.

- If you have to leave the braiding, complete the entire sequence so that you automatically restart with the first move.

You will need

Using Imposter kumihimo thread 105 in. (2.7 m) long

2 sections of #46 Turquoise

2 sections of #53 Pale Sky

Optional: A few beads to enhance the loop

8 small E-Z Bobs

Technique

This is a flat braid, with threads in eight positions. The disk is not turned during braiding—number 1 will remain at the top of the disk throughout. Hold the braid itself under the disk, with the disk resting on your hand.

Preparing the disk and threads

Tie the four sections together at the center with some strong sewing thread. (This will be used at the end to stitch the loop in place.) Wind all the threads onto E-Z Bobs.

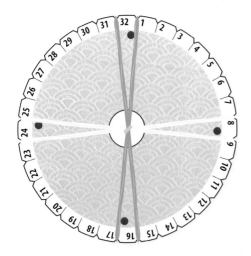
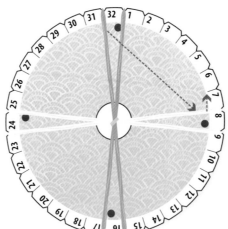
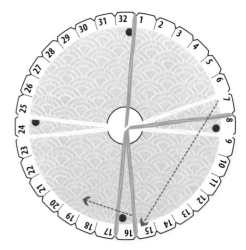

1 Set up the disk as per diagram, by placing Turquoise in positions 1 across to 17 and 32 across to 16, and Sky in positions 8 across to 24 and 9 across to 25. **Note:** Once on the disk, each of the eight threads will measure 52½ in. (1.35 m) from the hole. This is called a warp.

2 Open the side by moving 8 up to 7, and 32 down to 8.

3 Move 7 to 16, at the same time flicking 16 out to the left so that 7 can go into that space.

CONTINUED ON PAGE 52

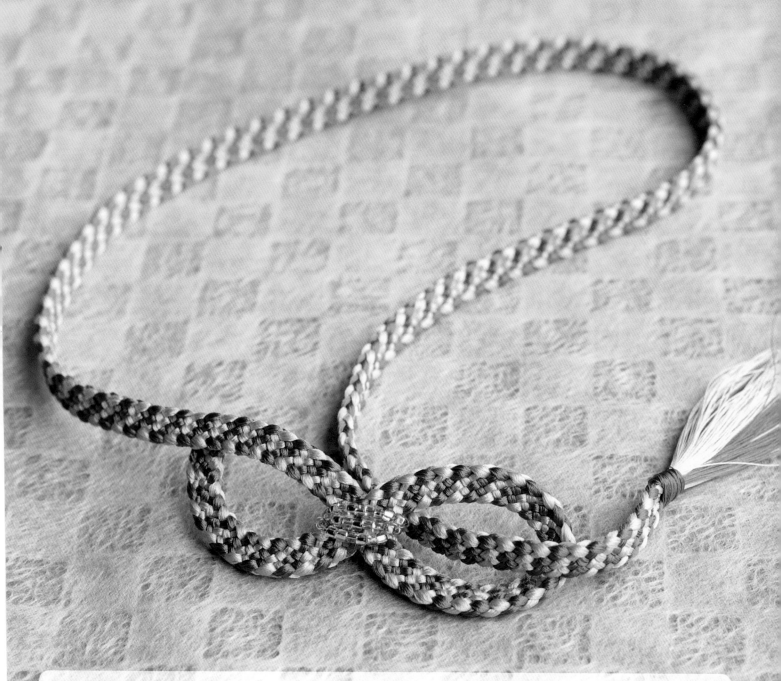

Finishing the lariat

1 Remove the braid from the disk. Make a tassel, either by tying a beautiful overhand knot or by following the instructions in the Techniques section (see page 32).

2 Trim the threads and steam the tassel.

3 Stitch the start end to the back of the braid to make a figure-eight loop, anchoring the thread inside the braid.

4 Add a couple of stitches where the braids cross, and embellish with some beads.

Finished length of braid approx. 32 in. (80 cm).

Finished length of necklace approx. 25 in. (63 cm).

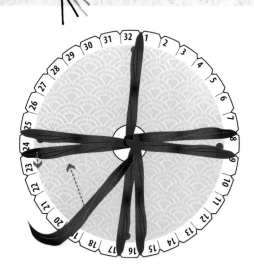

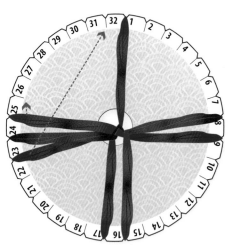

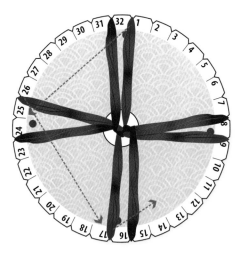

4 Open the side by moving 24 to 23 and then move the flicked 16 up to 24.

5 Move 23 to 32. **Note:** This is halfway. Now work back in the other direction, opening the side by moving 25 to 26.

6 Move 1 to 25 and 26 to 17, at the same time flicking 17 out to the right so that 26 can go into that space.

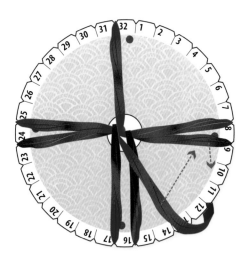

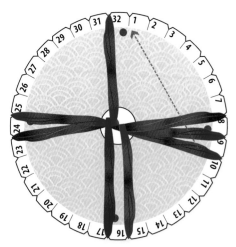

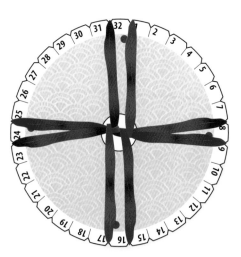

7 Move 9 to 10 and the flicked 17 to 9.

8 Move 10 to 1.

9 The disk is now ready to start the braiding sequence again.

10 Continue braiding, following the diagrams until the braid is approximately 30 in. (76 cm).

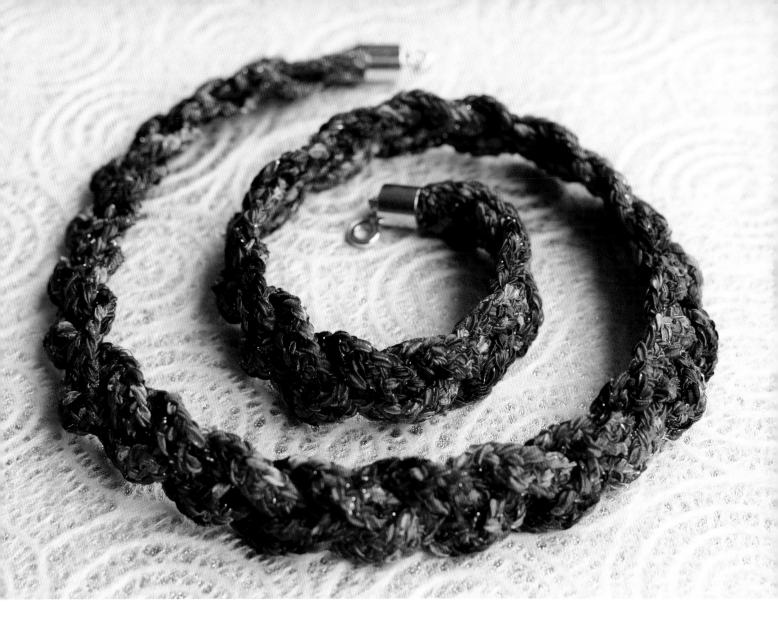

Finishing the necklace

1 Remove the braid from the disk, tie with an overhand knot, and put aside.

2 Once all the braids have been made, whip them together at the start end.

3 Braid the indivdual braids together. Note that the tighter the braid, the shorter the length.

4 Whip all the braids together at the end and trim the excess threads.

5 Apply some clear craft glue, and insert into the end caps.

Finished width approx. 1 in. (2.5 cm).

Finished length of necklace approx. 30 in. (76 cm).

Lemon Delicious Choker

This is a flat braid that forms a natural spiral as the braid progresses. There are threads in eight positions. As each thread is moved from the top, it replaces one at the bottom.

Be a better braider

- When using E-Z Bobs, keep them close to the disk and don't let them hang so far that they tangle.

- Don't pull the moves with the Bronze thread in step 3 too tight. They should lie within the width of the lemon braid.

You will need

Using kumihimo thread 105 in. (2.7 m) long

3 sections of Imposter in #22 Lemon

1 section of metallic in M46 Metallic Bronze

5 mm end caps and clasp set

8 small E-Z Bobs

Technique

This is a Flat 8 braid, with threads in eight positions, and it is worked in a zigzag fashion where the threads go up/down/up/down using the same slots, giving the spiral effect. Hold the braid itself under the disk, and keep number 1 at the top of the disk throughout. The same slots are used for the entire braid.

Preparing the disk and threads

Tie the threads together at the center to start with a neat end (see page 29) and place the tie in the hole of the disk. Wind all the threads onto E-Z Bobs.

Finishing the choker

See page 36 for instructions on how to finish the choker with end caps.

Finished length approx. 18 in. (45 cm).

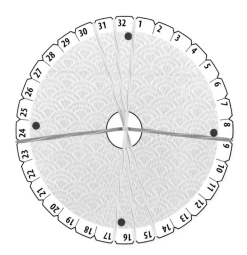

1 Set up the disk as per diagram, by placing Bronze in position 9 across to 24, and Lemon in position 31 across to 15, 32 across to 16, and 1 across to 17.

Note: Once on the disk, each of the eight threads will measure 52½ in. (1.35 m) from the hole. This is called a warp.

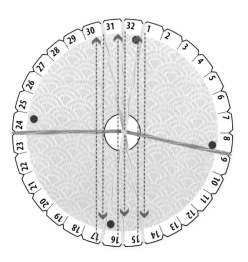

2 Move the top threads to replace the bottom, and the bottom threads to replace the top as follows: Move 1 to 15 and 15 to 1; move 32 to 16 and 16 to 32; move 31 to 17 and 17 to 31.

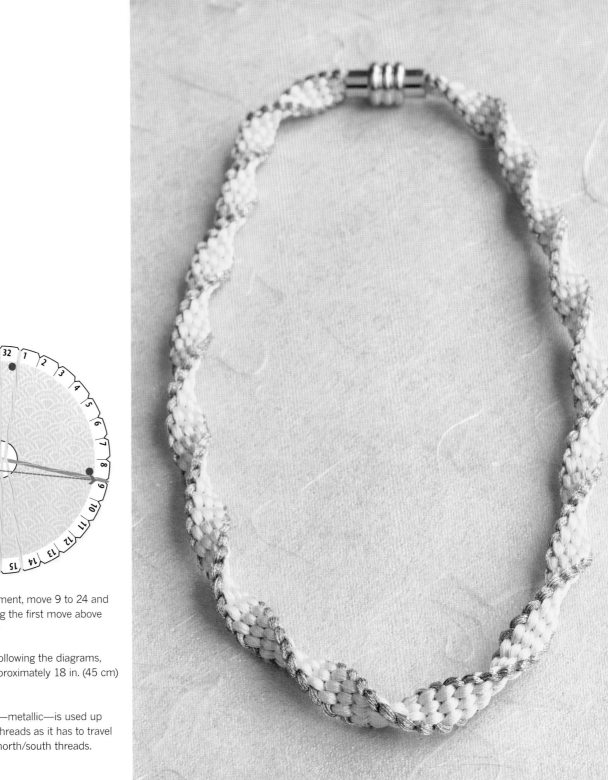

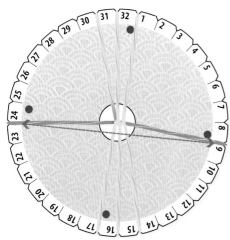

3 With a zigzag movement, move 9 to 24 and then 24 to 9, keeping the first move above the second.

4 Continue braiding, following the diagrams, until the braid is approximately 18 in. (45 cm) or the length required.

Note: The cross thread—metallic—is used up quicker than the other threads as it has to travel within the width of the north/south threads.

Twisted Spirals Necklace

This spiral braid is worked with threads of different thicknesses to give this unusual effect. The threads are in twelve positions on the disk, with the thicker threads gently twisted as they are moved.

SKILL	DISK
	●

Be a better braider

- Keep the side moves tight to make the three-dimensional braid show off the spirals.

- For separating kumihimo thread, see page 12.

- If you have not separated kumihimo floss into individual strands, you could use metallic embroidery floss cut to 105 in. (2.7 m).

You will need

Using kumihimo threads 105 in. (2.7 m) long

4 sections of Imposter #26 Purple

1 section of metallic #3 Green Sparkle divided into 4 lots of 10 individual strands

5 mm end caps and clasp set

8 small E-Z Bobs
4 medium E-Z Bobs

Technique

This spiral braid has thicker threads at the top and bottom of the disk, and fine ones at the sides. As the thicker threads are moved (top to bottom), gently twist them. When the fine threads are moved (side to side), keep them tight. The disk is not turned.

Preparing the disk and threads

- **Thick threads:** Place the Imposter on the disk with two (double) sections at each place. Gently twist them so that they seem as one. Wind onto medium EZ-Bobs.
- **Thin threads:** Divide the metallic thread into four lots of 10 individual strands, place them on the disk as in diagram 1, and wind onto small EZ-Bobs. Tie all the threads together at the center, with the tie through the hole in the disk.

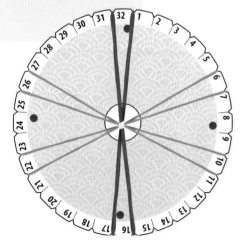

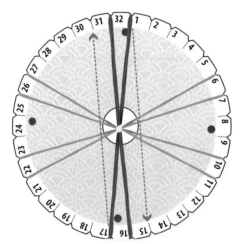

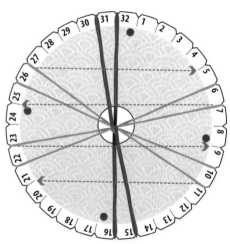

1 Set up the disk as per diagram, by placing two sections of Purple on top of each other and then across the disk in position 32 across to 16 and the other two sections on top of each other in position 1 across to 17. Place the groups of 10 individual strands of Green Sparkle in positions 6 across to 22, 7 across to 23, 10 across to 26, and 11 across to 27.

2 Move 1 to 15 and 17 to 31. Gently twist these threads as the moves are made.

3 Move 11 across to 21, 23 across to 9, 7 across to 25, and 27 across to 5. Keep these threads tight as the moves are made.

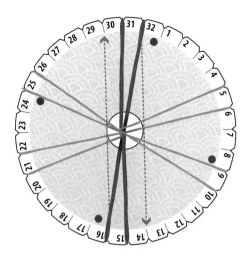

4 Move 32 to 14 and 16 to 30.

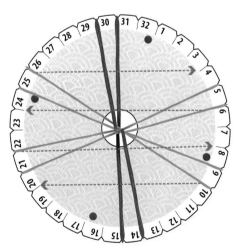

5 Move 10 to 20, 22 to 8, 6 to 24, and 26 to 4.

6 Continue braiding, following the diagrams until the braid is approx. 20 in. (50 cm) or the length required. **Note:** At the completion of the entire sequence, the spacing between the threads on the disk should be the same as it was at the start.

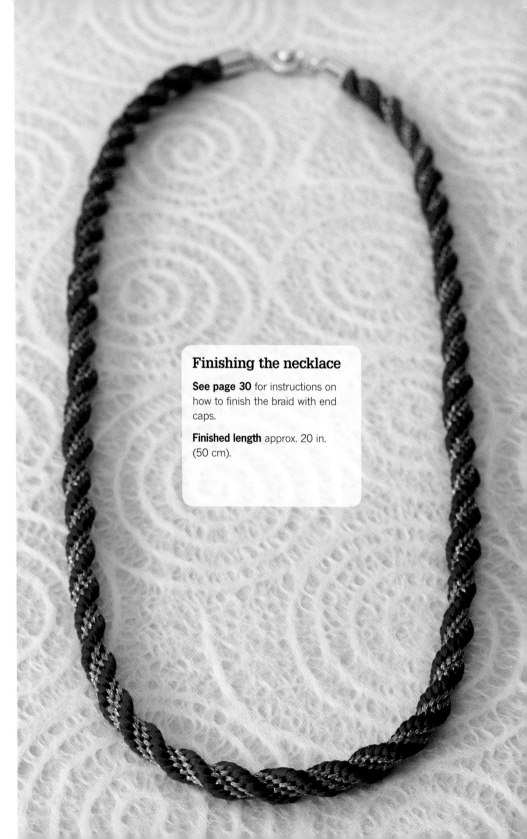

Finishing the necklace

See page 30 for instructions on how to finish the braid with end caps.

Finished length approx. 20 in. (50 cm).

Square Braided Bangle

This is a Square 8 braid, with eight warps (thread in eight positions); by using different colors, the shape of the braid can be seen. To achieve the thickness of the bangle, the threads are used double.

Be a better braider

- Take note of the layout of the threads. At the completion of each set of moves, the pairs of colors will be opposite each other. For example, this braid is started with Jade at the top and bottom. At the end of the first set of moves, Jade will be at the sides and Silver will be at the top and bottom of the disk.

- Keep the threads smooth by running them between your thumb and index finger.

You will need

Using Imposter kumihimo thread 105 in. (2.7 m) long

2 sections of #30 Ocean Jade

2 sections of #41 Warm Silver

1 large pewter bead with a hole approx. 8 mm, or 8 mm magnetic end caps and clasp set

Technique

The disk is not turned during braiding—position 1 should remain at the top and the braid itself be held under the disk during braiding. Begin by tying the middle of the threads together, to make a neat end to fit straight into a large hole bead or end cap.

Preparing the disk and threads

Fold each section of thread in half to use double. The length is now 52½ in. (1.35 m). Once the disk is set up, tie the threads together in the center to start with a neat end (see page 29). Place the tie in the hole in the disk. Hold this tie for the first few moves. Because the threads at each position (warps) are only 26¼ in. (67 cm) in length, it is not necessary to wind onto E-Z Bobs.

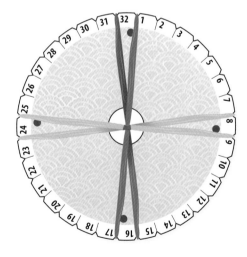

1 Set up the disk as per diagram, by placing Jade in positions 1 across to 17 and 32 across to 16, and Silver in positions 8 across to 24 and 9 across to 25.
Note: Cut the threads at the fold to make it easier to keep them smooth.

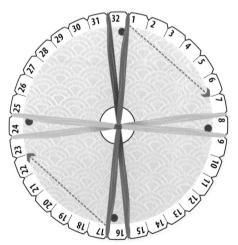

2 Move 1 down to 7 and 17 up to 23.

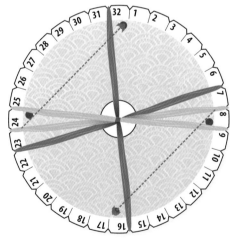

3 Move 24 up to 1 and 8 down to 17.

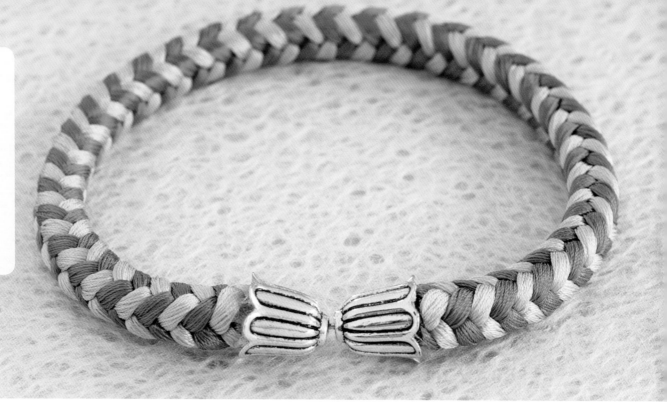

Finishing the bangle

See page 29 for instructions on how to finish the braid with a connector bead or page 36 to finish with end caps.

Finished length approx. 8 in. (20 cm).

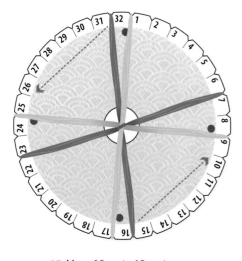

4 Move 16 up to 10 and 32 down to 26.

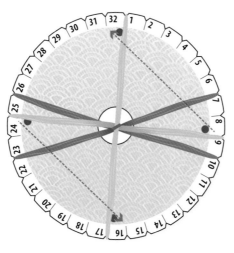

5 Move 25 down to 16 and 9 up to 32.

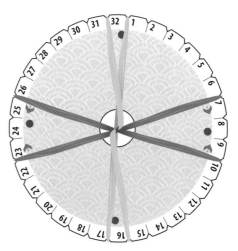

6 Reposition 7 to 8, 10 to 9, 23 to 24, and 26 to 25. Repeat steps 1 to 6 until the braid is the desired length.
Note This length of thread will make a braid approx. 12 in. (30 cm) long. Cut off the excess braid to make a bag pull (see page 74).

Spring Dawning Square Braid

This is a Square 8 braid, with thread in eight positions. By using threads of different thicknesses and keeping them twisted, you can have the glamour without having to bead the braid. Make it as a lariat with a tassel in the front.

SKILL DISK

Be a better braider

- Smooth the kumihimo threads by running them between thumb and forefinger.
- For separating kumihimo thread, see page 12.
- Twist the thicker threads in the same direction.
- If you have not separated kumihimo thread into individual strands, you could use metallic embroidery thread cut to 105 in (2.7 m).

You will need

Using kumihimo threads 105 in (2.7 m) long

4 sections of Imposter #19 Wine

2 lots of 10 individual threads taken from a section of kumihimo metallic thread #M46 Metallic Bronze

5 mm end caps and clasp set (optional)

4 medium E-Z Bobs
4 small E-Z Bobs

Technique

The disk is not turned during braiding and the braid itself is held under the disk throughout. It is important that the thick threads are kept in a smooth twist throughout and that they are all twisted in the same direction. The braid is started with a neat end and has the option of finishing with a tassel or end caps.

Preparing the disk and threads

- **Thin threads:** Separate out two lots of 10 strands each from the section of Bronze. Wind onto small E-Z Bobs.
- **Thick threads:** Place two sections of Wine across the disk from 1 to 17 and the other two sections from 32 to 16. Wind onto medium E-Z Bobs.

Tie the threads together in the center to start with a neat end (see page 29) and place the tie through the hole in the disk.

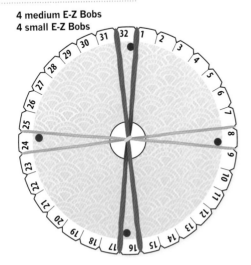

1 Set up the disk as per diagram, by placing Wine in positions 1 across to 17 and 32 across to 16, and Bronze threads in positions 8 across to 24 and 9 across to 25.

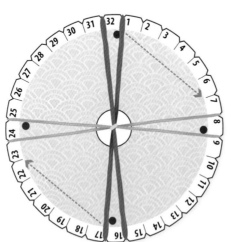

2 Move 1 down to 7 and 17 up to 23.

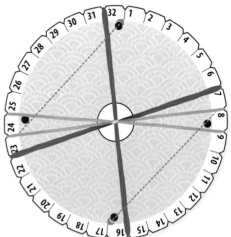

3 Move 24 up to 1 and 8 down to 17.

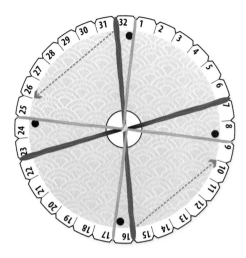

4 Move 16 up to 10 and 32 down to 26.

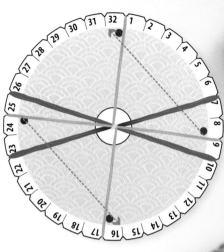

5 Move 25 down to 16 and 9 up to 32.

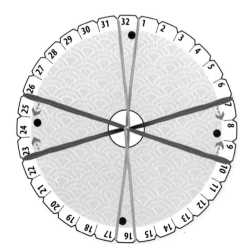

6 Move 7 to 8, 10 to 9, 26 to 25, and 23 to 24. Continue braiding, following the diagrams until the braid is 26 in. (65 cm) or the length desired. Smooth, twist, and rewind the thicker threads as necessary.

Finishing the necklace

To finish the braid as a necklace, remove the braid from the disk and fit the end caps.

Finishing as a lariat

1 Remove the braid from the disk.

2 Stitch the start end (neat end) into the finish end of the braid.

3 Make a tassel covering the stitching (see page 32).

Finished length approx. 26 in. (65 cm).

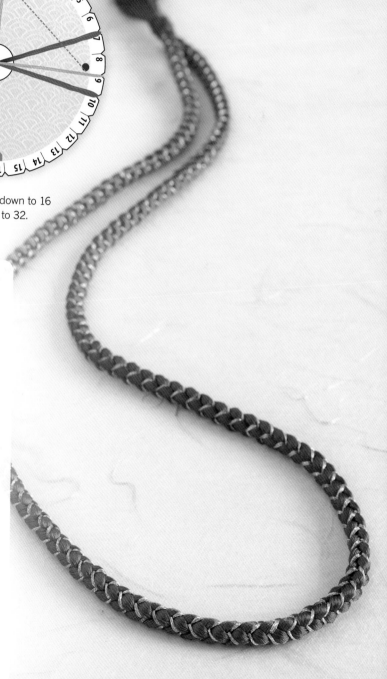

Manhattan Sunrise Square Braid

This is a square braid, with thread in eight positions. The cabochon appears to be suspended in a teardrop of golden braid. I bought the cabochon on a trip to New York and it goes with this braid perfectly.

You will need

Using Imposter kumihimo thread 105 in. (2.7 m) long

2 sections of #15 Gold

2 sections of #4 Goldenrod

Cabochon 1½ in. (4 cm) in diameter

5 mm end caps and clasp set

8 small E-Z bobs

Technique

The disk is not turned during braiding—position 1 should remain at the top and the braid itself held under the disk during braiding. It is started with a neat end (see page 29). Make sure that the threads are kept smooth throughout.

Preparing the disk and threads

Tie all the threads together at the center to start with a neat end (see page 29) and place the knot in the hole in the disk. Wind all threads onto E-Z Bobs.

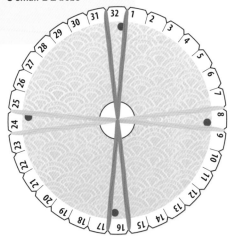

1 Set up the disk as per diagram, by placing Gold in positions 32 across to 16 and 1 across to 17, and Goldenrod in positions 8 across to 24 and 9 across to 25.

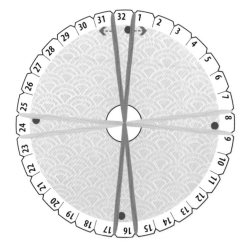

2 Open the top by moving 1 to 2 and 32 to 31.

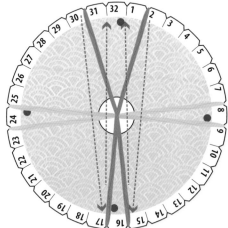

3 Move 16 up to 1 and 2 down to 16. Move 17 up to 32 and 31 down to 17.

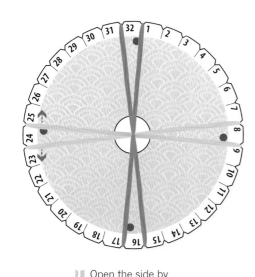

4 Open the side by moving 25 to 26 and 24 to 23.

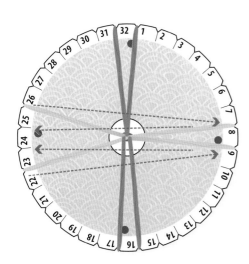

5 Move 8 across to 25 and 26 across to 8. Move 9 across to 24 and 23 across to 9.

6 Continue braiding, following the diagrams until the braid is 28 in. (70 cm) or the length desired.

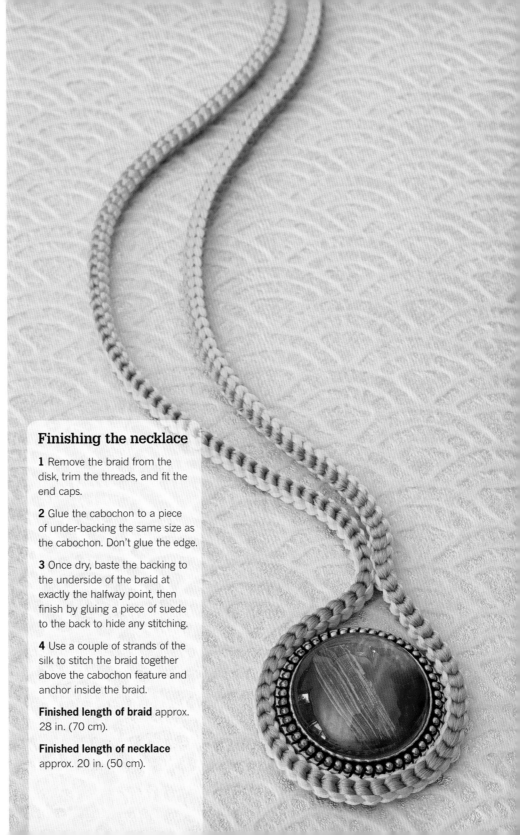

Finishing the necklace

1 Remove the braid from the disk, trim the threads, and fit the end caps.

2 Glue the cabochon to a piece of under-backing the same size as the cabochon. Don't glue the edge.

3 Once dry, baste the backing to the underside of the braid at exactly the halfway point, then finish by gluing a piece of suede to the back to hide any stitching.

4 Use a couple of strands of the silk to stitch the braid together above the cabochon feature and anchor inside the braid.

Finished length of braid approx. 28 in. (70 cm).

Finished length of necklace approx. 20 in. (50 cm).

Stained Glass Window Collar

This hollow braid looks stunning in hand-dyed silk, metallic threads, or a combination of both. The thread for this project has been used double. Because the braid is hollow, it can be flattened to make this beautiful collar.

You will need

Using Exotic Lights silk thread

2 skeins, total length 17 yd. (16 m), #27 Purple Genie

2 skeins, total length 17 yd (16 m), #15 Marrakesh

8 mm end caps and clasp set

16 small E-Z Bobs

Technique

This is a hollow braid, with thread in sixteen positions. The threads are woven around the disk first in a clockwise direction, then in a counterclockwise direction. The main color will go clockwise and remain to the left of the contrast color. The contrast thread goes counterclockwise.

To enable the thread to go into the next slot, lift the thread that's already there out of the way, in the direction of braiding.

Example: To move 32 to 4, lift 4 out toward 8, so that 32 can go into slot 4. To move 4 to 8, lift 8 out toward 12, so that 4 can go into slot 8, and so on. As you can see, it's a "lift and place" movement.

Preparing the disk and threads

Cut the Purple thread into four equal 4¼-yd. (4-m) lengths and fold each in half to use double = 4 x 76-in. (2-m) lengths. Place straight onto the disk as detailed in step 1. Repeat the process for the Marrakesh thread. Tie all the threads together at the center to start with a neat end (see apge 29) and place the tie through the hole in the disk. Wind the threads onto E-Z Bobs.

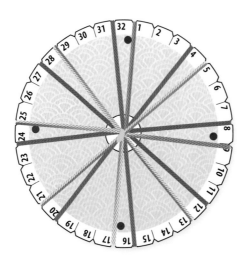

1 Set up the disk as per diagram, by placing the **main color** (Purple) at positions 32 across to 16, 4 across to 20, 8 across to 24, and 12 across to 28. Set up the **contrast color** (Marrakesh) at positions 1 across to 17, 5 across to 21, 9 across to 25, and 13 across to 29.

Now that the disk is set up, each warp—the length of thread from the center hole to the end—will be 38 in. (1 m).

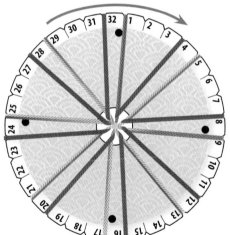

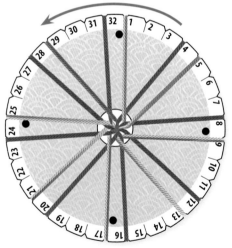

Finishing the necklace

See page 30 for instructions on how to finish the braid with end caps.

Finished length approx. 20 in. (50 cm).

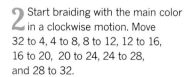 Start braiding with the main color in a clockwise motion. Move 32 to 4, 4 to 8, 8 to 12, 12 to 16, 16 to 20, 20 to 24, 24 to 28, and 28 to 32.

The diagram above shows how the disk will look after the above moves.

3 Start braiding with the contrast color in a counterclockwise motion. Move 1 to 29, 29 to 25, 25 to 21, 21 to 17, 17 to 13, 13 to 9, 9 to 5, and 5 to 1.

The diagram above shows how the disk will look after the above moves.

4 Continue braiding, following the diagrams until the braid is approximately 20 in. (50 cm) or the length required.

Kumihimo Surprise Necklace

This technique can be used to give a truly unique braid. The Round 8 braid in variegated silk pops in and out of the main braid. This can be done along the braid as randomly as desired.

Technique

This project uses the beginner Round 8 technique already covered on page 36. The variegated Round 8 braid is started with a neat end and is made first. The main Round 8 braid is worked around the variegated braid. Regularly stretch the main braid over the variegated by holding the tail of the variegated.

You will need

 1 17-yd (16-m) length of Exotic Lights hand-dyed silk #16 Seascape

4 sections, each 105 in. (2.7 m) long, Imposter kumihimo thread #52 Midnight

8 mm end caps and clasp set

8 small E-Z Bobs

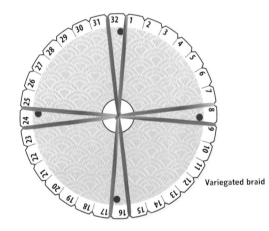
Variegated braid

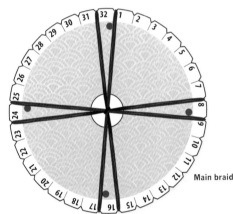
Main braid

SKILL | DISK

Be a better braider

Kumi-calculation, main braid:

- Once the first 6 in. (15 cm) of the variegated braid has been braided around, measure the remaining thread of one warp. Deduct this from the starting length of the thread—52 in. (135 cm)—to see how much has been used. You'll need this amount to work around the 6 in. (15 cm) at the other end. In this case, there was 35 in. (90 cm) left, therefore the amount of thread needed to cover each 6-in. (15-cm) section is 17 in. (45 cm).

- Stretch the middle section of the main braid to its full length before twisting and reinserting the variegated braid, ready for the last 6-in. (15-cm) section.

Preparing the threads and disk: variegated braid

Cut the Seascape thread into four equal lengths and place directly onto the disk. Tie the threads at the center to start with a neat end and wind onto E-Z Bobs.

1 Set up the disk as per diagram above.

2 Follow braiding instructions as for My First Kumihimo Braid (see page 36) to make a Round 8 braid approximately 40 in. (100 cm) long. Remove the finished braid from the disk and tie with an overhand knot.

3 Place a thread marker 6 in. (15 cm) from each end and at the halfway point to mark where the variegated braid will exit and re-enter the main braid.

Preparing the threads and disk: main braid

Place the four sections of Midnight Imposter thread straight onto the disk and tie together at the center to start with a neat end. Wind threads onto E-Z Bobs.

1 Set up the disk as per diagram above to start a Round 8 braid.

2 Follow braiding instructions as for My First Kumihimo Braid (see page 36) to work approximately ½ in. (1 cm).

3 Insert the variegated braid into the center of the main braid, using its tail end to pull it inside the start of the main braid.

4 Continue braiding around the variegated braid to the 6-in. (15-cm) marker (see step 3 of variegated braid).

5 Bring the variegated braid to the outside of the main braid by threading it down between two main threads and underneath the disk (see image below).

6 Continue working the main braid on its own without the variegated braid. Refer to the calculation opposite—you'll need 17 in. (45 cm) of Midnight left to braid the last 6 in. (15 cm) of main braid. Therefore, this section of the main braid will be 8 in. (20 cm).

7 Twist the variegated braid around the main section just braided, then bring it back up through two main threads to the top of the disk.

8 Finish the second side to match the first by braiding around the variegated braid.

9 Once anchored back in the main braid, whip around the end of the variegated and trim, so that you can braid straight over the top.

10 See page 30 for instructions on how to finish the braid with end caps.

This is how the loop will look, under the disk, once the two sides have been braided.

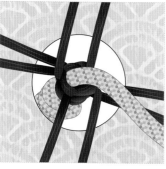

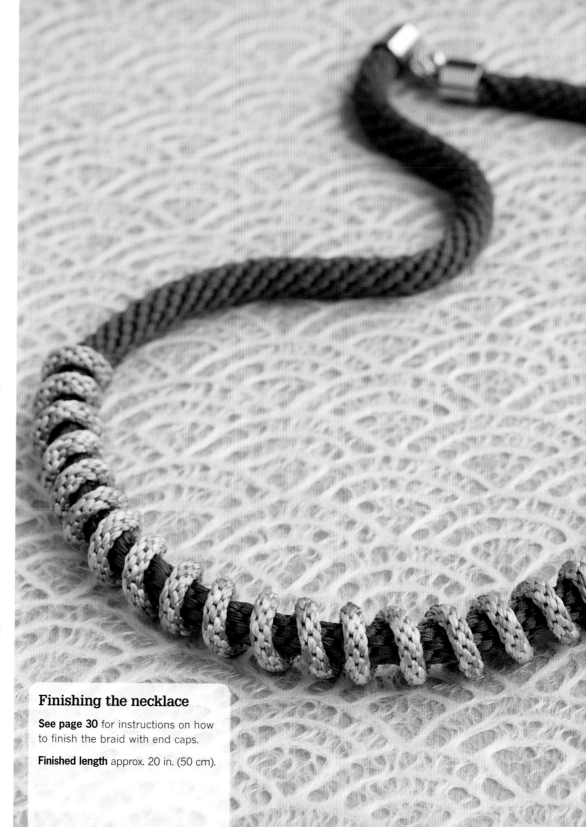

Finishing the necklace

See page 30 for instructions on how to finish the braid with end caps.

Finished length approx. 20 in. (50 cm).

Lavender Fields Necklace

This necklace can be as free-form as you like, by splitting a Round 16 braid into two Round 8 braids, then splicing it back into the Round 16. This is the easiest setup for a braid of this type. It requires patience and skill, but is well worth the effort.

SKILL	DISK
❀❀❀	

Be a better braider

- Use any type of single-ply thread such as pearl cotton #3 or embroidery silk.

- The important measurement to start with is the length of the warp. In this case, it's 6½ ft. (2 m). You'll need to start with this length to make the braid 28 in. (70 cm).

- The threads will have to be unwound from the E-Z Bobs when they are removed from the disk. You can rewind for each section or run your fingers through the threads being used. This will keep them tangle free. Use the bobbins for the longer sections of braid.

You will need

Using Exotic Lights hand-dyed silk thread

 Two 17-yd. (16-m) lengths of #21 Purple Genie

 Two 17-yd. (16-m) lengths of #1 Wisteria

5 mm end caps and clasp set

16 small E-Z Bobs

Technique

This project uses two different braiding techniques already covered—Round 16 and Round 8—as well as splitting and splicing. It starts with an overhand knot and thread in sixteen positions. Refer to the Rose Trellis Necklace (see page 42) for Round 16 technique and braiding instructions and My First Kumihimo Braid (see page 36) for Round 8 technique and braiding instructions. Follow the steps and you'll have a wonderfully interesting result. The measurements given for the braided sections ensure even usage of the thread.

Preparing the disk and threads

Cut eight equal lengths of each color, and tie them together at one end with an overhand knot. Place the knot in the hole of the disk and the threads around the disk, as per the diagram below. Wind onto E-Z Bobs.

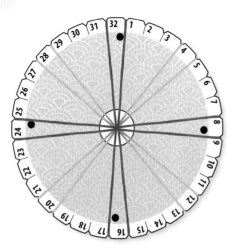

1 Set up the disk as per diagram, by placing Purple thread in positions 32, 1, 8, 9, 16, 17, 24, and 25, and Wisteria thread in positions 4, 5, 12, 13, 20, 21, 28, and 29.

2 Follow braiding instructions as for the Rose Trellis Necklace (see page 42) to make a Round 16 braid approximately 4 in. (10 cm) long.

3 Remove the Purple threads from the disk and thread them down through the hole in the disk.

4 Using only the Wisteria thread, work 2 in. (5 cm) as a Round 8 braid (see page 36 for instructions).

5 Remove the Wisteria threads and braid from the disk and tie the end of the braid with a slip knot to prevent it from raveling.

6 Replace the Purple threads to their original positions either side of the dots and work a 1-in. (2.5-cm) Round 8 braid.

7 Twist the Wisteria braid around the Purple braid.

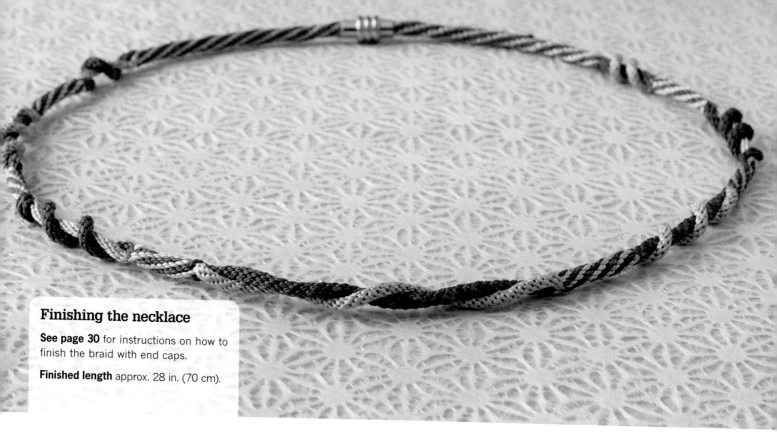

Finishing the necklace

See page 30 for instructions on how to finish the braid with end caps.

Finished length approx. 28 in. (70 cm).

8 Bring the Wisteria threads back up through the hole, unknot, and reposition the sixteen threads as per step 1.

9 Work a 1-in. (2.5-cm) Round 16 braid.

10 Repeat steps 3 through 9, using the reverse colors and lengths as detailed.

11 Continue the second half of the necklace by reversing the sections and colors from section 7 back to section 1. Refer to the table and diagram at right.

SECTION BRAIDS, COLORS, AND MEASUREMENTS

Section	Round	Description
Section 1	Round 16	Mixed 4 in. (10 cm)
Section 2	Round 8	Wisteria 2 in. (5 cm) twisted around Purple 1 in. (2.5 cm)
Section 3	Round 16	Mixed 1 in. (2.5 cm)
Section 4	Round 8	Purple 3 in. (7.5 cm) twisted around Wisteria 2 in. (5 cm)
Section 5	Round 16	Mixed 1 in. (2.5 cm)
Section 6	Round 8	Wisteria 3 in. (7.5 cm) twisted around Purple 2 in. (5 cm)
Section 7	Round 16	Mixed 1 in. (2.5 cm)
Section 8	Round 8	Purple 5 in. (12 cm) twisted Wisteria 5 in. (12 cm)

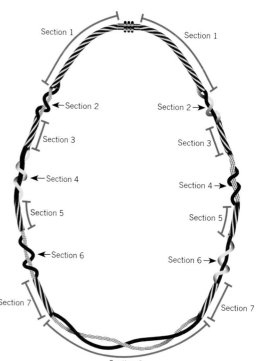

Section 1 Section 1
Section 2 → ← Section 2
Section 3 Section 3
← Section 4 Section 4 →
Section 5 Section 5
← Section 6 Section 6 →
Section 7 Section 7
Section 8

Frou Frou Braided Necklace

Make this fun braid using felting Frou Frou, or eight threads of different textures. Wear it as is, twisted, doubled, or fashioned as per the photograph using a row of slip knots.

Be a better braider

- Either tie a couple of medium E-Z Bobs to the start end to act as a counterweight, or gently hold the braid under the disk. This will enable you to ease any feathery bits to the outside of the braid.

- When putting this braid down, use the slots to hold the threads.

You will need

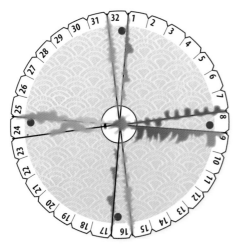

Colourstreams felting Frou Frou containing at least 8 threads of different textures, each 2 yd. (2 m) long

6.5 mm end caps and clasp set

8 small E-Z Bobs Optional: A couple of medium E-Z Bobs to act as weights

Technique

This is a Round 8 braid, with thread in eight positions. To achieve a softer look, rest the threads at their positions, rather than using the slots; the absence of tension usually provided by the slots gives a looser look to the braid.

Preparing the disk and threads

Separate the lengths of thread into eight lots. Sometimes the skeins contain very thin threads, which can be combined. Tie them together at one end with an overhand knot. This will later be cut off to fit the end cap. Place the knot in the hole of the disk and position the threads for a Round 8 braid. Wind all the threads onto E-Z Bobs.

1 Set up the disk as per diagram, by placing the threads in positions 32 across to 16, 1 across to 17, 8 across to 24, and 9 across to 25.

2 Follow braiding instructions as for My First Kumihimo Braid (see page 36) to make a Round 8 Braid approximately 60 in. (150 cm) long. Remove it from the disk and tie an overhand knot to prevent the braid from raveling.

Finishing the necklace

1 Using a crochet hook or tapestry needle, flick out any feathery bits that may have been caught up in the braiding.

2 See page 30 for instructions on how to finish the braid with end caps.

3 To finish as in the photo, finger-braid several slip knots at the center front of the braid, as per the picture below. The beauty of doing this type of knot is that it can easily be undone to wear the piece in other ways.

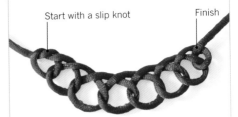

Start with a slip knot Finish

Finished length of braid approx. 60 in. (150 cm).

Finished length of necklace approx. 20 in. (50 cm).

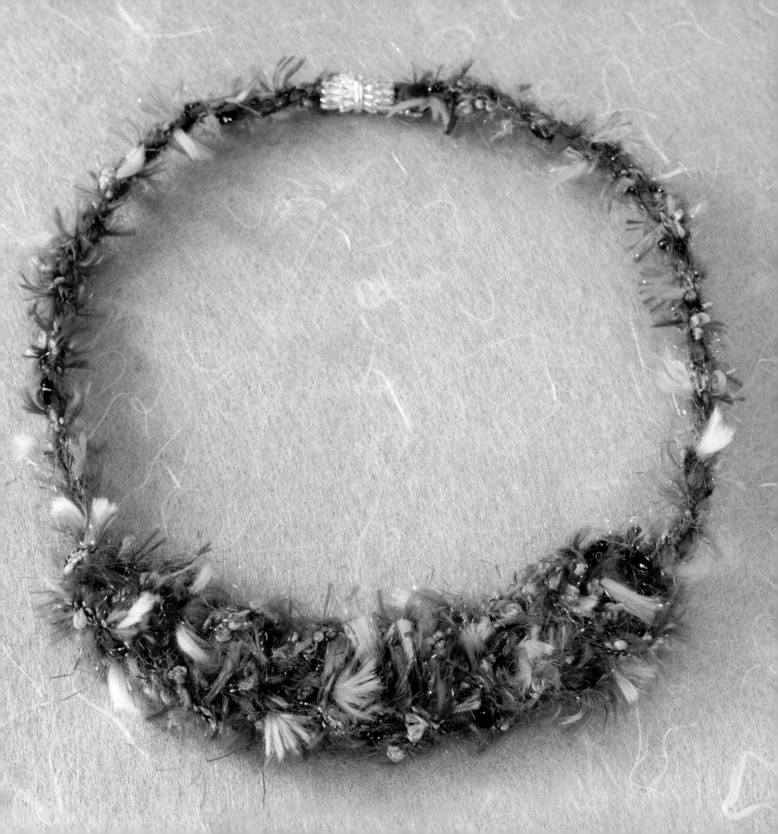

Blue Knotted Bag Pull

Your very first kumihimo braid on the square plate is a Flat 8 braid, which is very quick and easy to make and therefore ideal for the beginner. The more advanced braider can use this braid to show off the beautiful colors and textures of unusual threads.

SKILL	DISK

Be a better braider

- Keep an eye on the threads at the hole of the plate—the point of braiding—as they should remain in the center of the hole (see page 22).
- The right side of the braid is the side farthest away from you.
- For this braid, I used 4-ply crochet cotton. You could also use pearl cotton #3, yarn, or embroidery floss.
- When putting the plate down, make sure you finish the entire braiding sequence so that when you return, you start at the beginning.

You will need

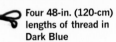

Four 48-in. (120-cm) lengths of thread in Dark Blue

Four 48-in. (120-cm) lengths of thread in Light Blue

1 lobster key fob clasp

Technique

This is a flat braid, with threads in eight positions on the plate. The braid is made directly onto the key fob. The plate is not turned, but kept in the same position throughout. The braid itself is held under the plate during braiding. It is not necessary to wind these short lengths of thread onto bobbins. Run your fingers through the threads to keep them tangle free.

A note regarding the length: Once the plate is set up, each warp will be 24 in. (60 cm) long, resulting in a braid 12 in. (30 cm) long. Therefore, to make a 24-in. (60-cm) braid, you will need twice the starting length or 48 in. (120 cm) per warp. Remember, a warp is the measurement from the center hole to the end of the thread.

Preparing the plate and thread

Fold the threads in half to use double and, using a lark's head knot (see page 26), attach to the key fob. Place the fob into the hole on the plate, with the threads on top.

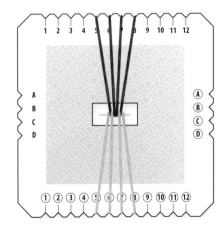

1 Set up the plate as per diagram, by placing Dark Blue in positions 5, 6, 7, and 8, and Light Blue in positions ⑤, ⑥, ⑦, and ⑧. The thread is being used double, so there will be two threads at each position.

2 Move 6 down to Ⓑ and 7 down to B.

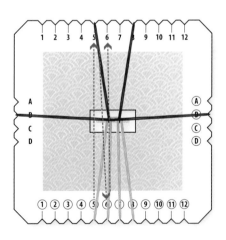

3 Move ⑥ up to 6, 5 down to ⑥, and ⑤ up to 5.

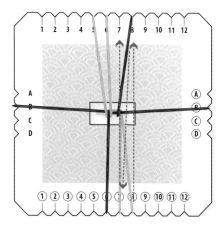

4 Move ⑦ up to 7, 8 down to ⑦, and ⑧ up to 8.

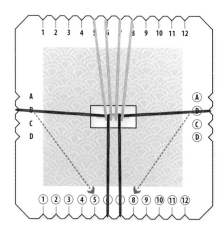

5 Move ⑧ down to ⑧ and B down to ⑤. The sequence is now complete. Continue braiding, repeating steps 2 through 5, to make a braid approximately 12 in. (30 cm) long.

Finishing the pull

1 Remove the threads from the plate. To do this, hold the threads under the plate close to the point of braiding.

2 Lift each thread out of the slots and remove the plate.

3 Make a tassel and trim the threads.

4 Fashion into a decorative knot or tie (a double coin knot is shown here). The fancier the knot, the longer the braid will have to be.

Finished length of braid approx. 12 in. (30 cm).

Finished length of pull approx. 5 in. (12 cm).

Double coin knot

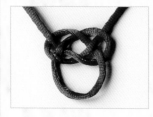

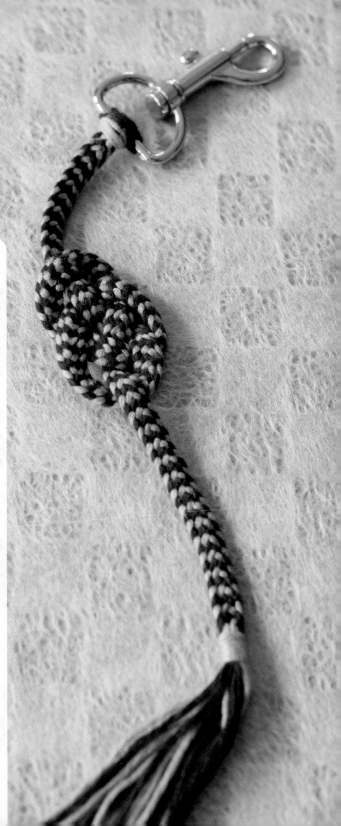

Chevron Bookmark

This bookmark will have all your friends wanting one. It is a flat chevron braid in three colors and is worked on the kumihimo plate. This little braid is started with a loop and finished with a tassel—just the thing to mark your place in this book.

SKILL	DISK

Be a better braider

- When making the loop, hold the plate with your knees so that both hands are free to braid.

- Keep hold of the whipping around the loop when setting up the plate and for the first few moves to prevent the loops from collapsing.

- You could also use pearl cotton, hand-dyed silk thread, or embroidery floss.

You will need

Using Exotic Lights thread 6 ft. (180 cm) long

2 lengths of #52 Cotswold Stone

2 lengths of #2 Water Nymphs

2 lengths of #19 Verde

Technique

This is a flat braid with threads in twelve positions on the plate. By using three colors, you will see a chevron pattern forming in the braid. It is started with a braided loop and finished with a tassel. The braid itself is held under the plate during braiding.

Preparing the plate and threads

The plate is first prepared to make the braided loop, which is covered in detail on page 30. Once this has been done, the plate can be set up to make the braid, by putting the loop in the hole and the threads on top of the plate in the starting position for the braid. The threads have been used double to show off the pattern detail.

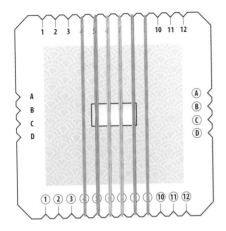

Starting the braided loop

1 Set up the plate as per diagram, by placing Stone in positions 6 across to ⑥ and 7 across to ⑦, Water Nymphs in positions 5 across to ⑤ and 8 across to ⑧, and Verde in positions 4 across to ④ and 9 across to ⑨.

2 Remove the threads from the bottom positions and create a braided loop 3 in. (7.5 cm) long (see page 30).

Starting the braid

3 Set up the plate ready for braiding, as in step 1. This time, the loop will be in the hole and the threads placed in the starting position.
Note: Make sure you keep hold of the whipping while setting up the plate to prevent the loops from collapsing.

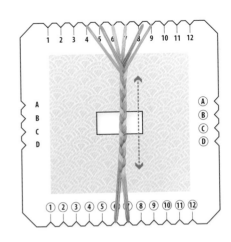

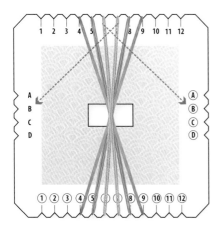

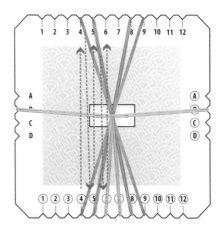

4 Move 6 down to Ⓑ and 7 down to B.

5 Move ⑥ up to 6, 5 down to ⑥, ⑤ up to 5, 4 down to ⑤, and ④ up to 4.

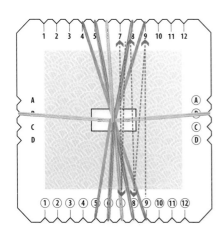

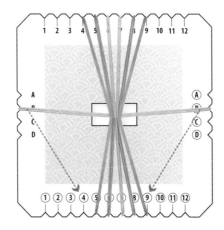

6 Move ⑦ up to 7, 8 down to ⑦, ⑧ up to 8, 9 down to ⑧, and ⑨ up to 9.

7 Move ⑧ down to ⑨ and B down to ④. The sequence is now complete.

8 Continue braiding, following the diagrams to make a braid approx. 10 in. (25 cm) long.

Finishing the bookmark

See page 32 for instructions on how to finish the braid with a 4-in. (10-cm) tassel or beaded tassel.

Finished length approx. 15 in. (38 cm).

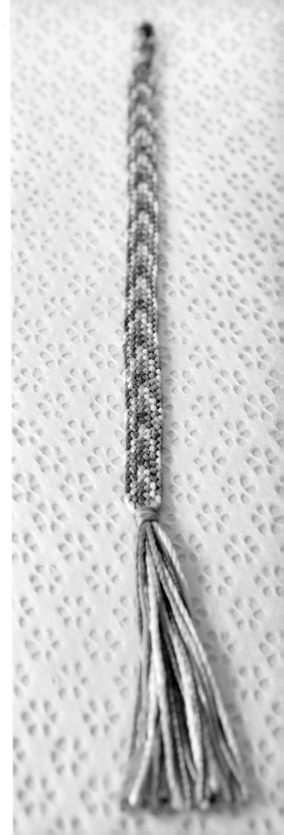

A Braid for Jasmine

This rounded, flat braid can be finished with end caps or with a loop and tassel for a more glamorous look. This braid looks fit for a princess, so I named it for my own little princess, Jasmine.

 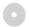

Be a better braider

- Smooth out the kumihimo threads by running them between your thumb and forefinger.
- Long lengths of thread left? Knot them at the end before cutting, then use for a small project.
- See page 12 for instructions on separating kumihimo threads.

You will need

4 sections, 105 in. (2.7 m) long of Imposter kumihimo thread #62 Grape

4 lots of 7 individual strands taken from a section of kumihimo Metallic Silver thread 105 in. (2.7 m) long

Approx. 60 size 11 beads for the loop

8 mm end caps and clasp set (optional)

12 small E-Z Bobs

Technique

This is a rounded, flat braid, with thread in 12 positions, and it's started with a neat end. The thick threads at 32, 1, 16, and 17 are double sections of kumihimo thread. There are approximately seven individual strands of metallic thread in each of the other eight positions.

The disk is not turned during braiding and the braid is held under the disk throughout.

Preparing the disk and threads

Place the threads on the disk in the starting position, as per the diagram below. Tie the threads together at the center and wind them onto E-Z Bobs.

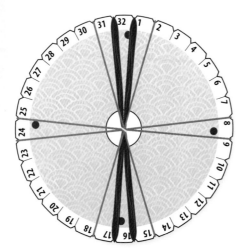

1 Set up the disk as per diagram, by placing two sections of Grape in position 32 across to 16 and another two sections in position 1 across to 17. Place the groups of seven individual strands of Silver in positions 31 across to 15, 2 across to 18, 8 across to 24, and 9 across to 25.

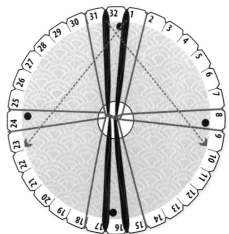

2 Move 32 down to 10 and 1 down to 23.

CONTINUED ON PAGE 80 ▶

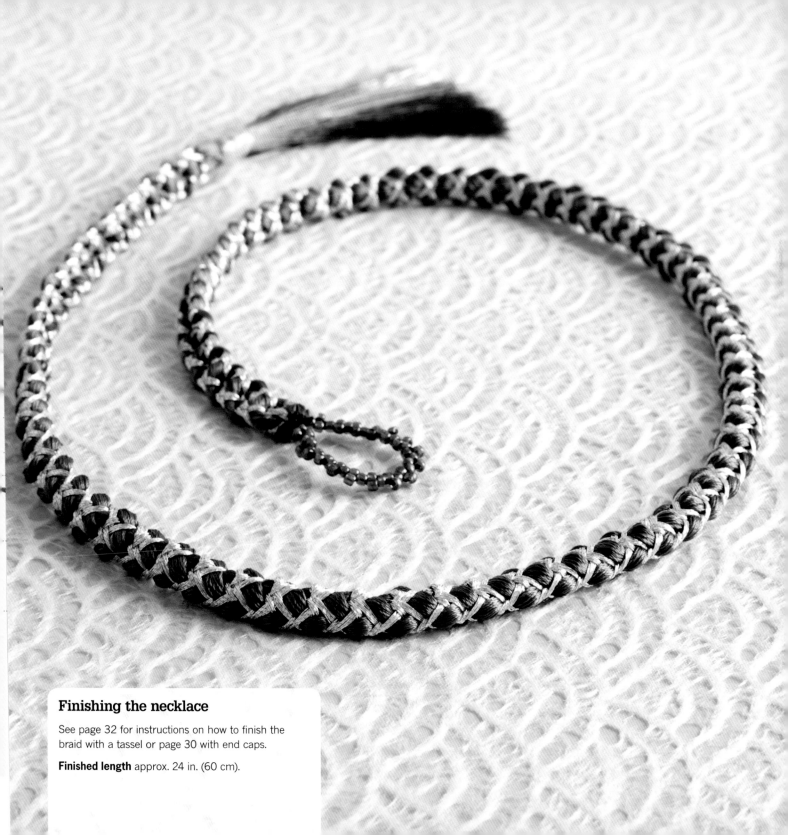

Finishing the necklace

See page 32 for instructions on how to finish the
braid with a tassel or page 30 with end caps.

Finished length approx. 24 in. (60 cm).

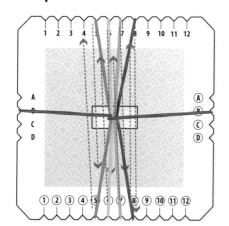

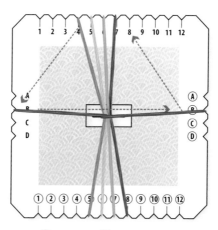

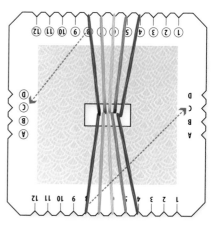

3 *Move ⑤ to 4, 5 to ⑤, ⑥ to 5, 6 to ⑥, ⑦ to 6, 7 to ⑦, ⑧ to 7, and 8 to ⑧.

4 Move ⑧ to 8, B to ⑧, and 4 to B**. Repeat from * to ** 8 times.

5 Repeat step 3 once more. Move ⑧ to 8 and B to ④. The threads are now back in the starting position.

6 Rotate the plate by 180 degrees so that the numbers in circles are now at the top.

7 Move ⑧ down to ⓒ and 8 up to C.

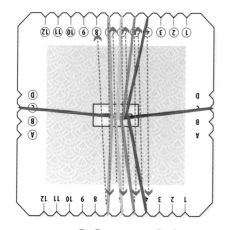

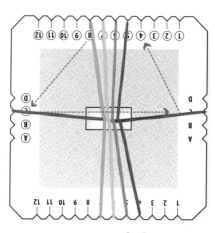

8 *Move 7 to ⑧, ⑦ to 7, 6 to ⑦, ⑥ to 6, 5 to ⑥, ⑤ to 5, 4 to ⑤, and ④ to 4.

9 Move C to ④, ⓒ to C and ⑧ to ⓒ**.

10 Repeat from * to ** 8 times. Repeat step 9 once more. Move ⓒ to 8 and C to ④.

11 Rotate the plate 180 degrees so that the numbers in circles are at the bottom. The threads are now back in the starting position and ready to restart from step 2.

12 Continue braiding, following the diagrams, until the braid is 18 in. (45 cm).

Finishing the necklace

Zigzag braid

1 See page 30 for details on how to finish the braid with the 8mm end caps.

2 Stitch the center front peaks together to form a flower shape at the center of the necklace.

Round braid

1 Starting with a neat end, make a Round 8 braid approximately 10 in. (25 cm) long (see page 36 for instructions).

2 Remove the braid from the disk, whip around the finish end, and fit the claspless 5 mm end caps (see page 30).

3 To cut the braid in half, whip around either side of the middle of the braid and cut between the two lots of whipping.

4 Fit another pair of end caps with clasp.

5 To assemble the project, link the end caps of the two braids with jump rings.

Finished length of zigzag braid
approx. 18 in. (45 cm).

Finished length of necklace
approx. 22 in. (55 cm).

Golden Rhapsody Necklace

This is an ideal project for your first beaded braid. It is a Round 8 braid with the same beads used on all eight threads. It is a simple braid as there is no bead pattern to follow, but it makes a striking necklace.

SKILL	DISK

Be a better braider

- If you don't have a beading tray, use a flat plate with a piece of felt in it to keep the beads in one place while threading them onto the silk or cord.

- Move ten beads at a time up onto the disk to keep check on the number of beads used, particularly when you're new to beaded braids. They should be used up at the same rate.

- Don't let the beads go into the slots of the disk, as this could damage it.

- Use braiding cord as an alternative to the silk.

You will need

9 yd. (8 m) Exotic Lights silk #37 Uluru

40 g size 6 silver-lined gold seed beads (approx. 650 beads)

5 mm end caps and clasp set

8 small E-Z Bobs

Technique

The beads are threaded onto the braiding cord or silk before you begin and then released one at a time.

When releasing the beads, make sure they do not go inside the braid. Keep checking that they are standing up on the outside of the braid. The best way is to move the bead, then move the thread. See page 27 for more detailed instructions on releasing the beads.

Preparing the disk and threads

- Cut four equal lengths of thread and tie together at the center for a neat end. Set up the disk in the normal way for a Round 8 braid, with a thread either side of the dots (see below).
- Divide the beads into eight even piles—there will be about 80 beads in each pile.
- Using a beading needle and leader thread (see page 26), slide them onto the eight threads.
- Wind each thread onto a small E-Z Bob as you go.

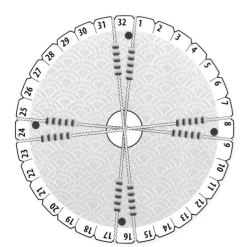

1 Set up the disk as per diagram, by placing threads in positions 32 across to 16, 1 across to 17, 8 across to 24, and 9 across to 25.

2 Follow braiding instructions as for My First Kumihimo braid (see page 36) to make a Round 8 braid about ½ in. (1 cm) long without any beads. This will go into an end cap when the braid is finished.

3 Start releasing one bead at a time with every move, and continue until the braid is 19½ in. (49 cm) long.

4 Work another ½-in. (1-cm) section without any beads.

Finishing the necklace

See page 30 for instructions on how to finish the braid with end caps.

Finished length approx. 20 in. (50 cm).

Finished width approx. ½ in. (1 cm).

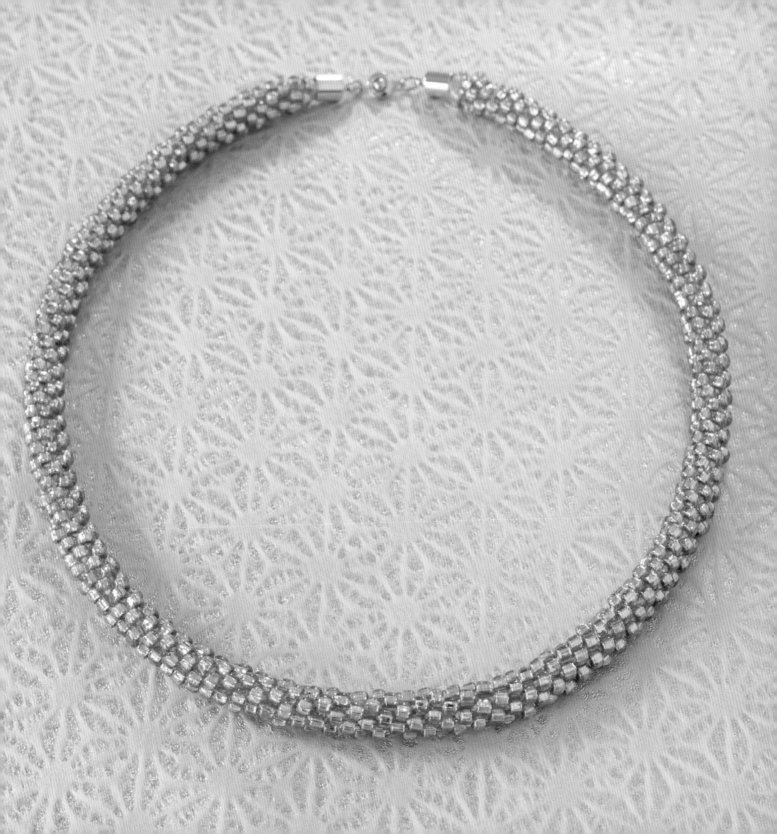

Monet Beaded Bracelet

This is a Round 8 braid, with threads in eight positions and beads on just four of the threads. The positioning of the beads gives a spiral appearance. Attach the bracelet to a plain braid to wear as a necklace.

SKILL	DISK

Be a better braider

- To determine the length of the braid, measure the clasp/toggle you are going to use and deduct this from the length required.

- When using double thread, thread the beads from a folded end, then slide half of them across to the opposite side.

- Remember the chant, "right comes, left goes."

You will need

Four 6½-ft. (2-m) lengths of Exotic Lights silk #14 Monet or pearl cotton #3

20 g size 6 green iris seed beads, to match the thread (approx. 200 beads)

8 mm end caps and clasp set

8 small E-Z Bobs

Technique

This is a Round 8 braid started with a neat end. The beads are threaded onto the silk before you begin and then released one at a time while making the braid. When releasing the beads, make sure they do not go inside the braid. They must be standing up on the outside of the braid.

The best way is to move the bead, then make the braiding move. See page 27 for more detailed instructions on releasing the beads.

Preparing disk and threads

- Fold each of the four lengths of thread in half to use double.
- Set up the disk in the normal way for a Round 8 braid, with a thread either side of the dots (see below).
- Divide the beads into two equal piles of approx. 100 beads.
- Using a beading needle and leader thread (see page 26) in the folded end of the threads at the side positions, slide the beads onto the four threads.
- Slide half of these beads (50) over to the other side of the threads. There will be approx. 50 beads at positions 8, 9, 24, and 25 (see diagram). The other positions—32, 1, 16, and 17—are plain thread.
- Wind onto E-Z Bobs as you go.
- Tie the threads together at the center for a neat end start.

1 Set up the disk as per diagram, by placing threads in positions 32 across to 16, 1 across to 17, 8 across to 24, and 9 across to 25.

2 Follow braiding instructions as for My First Kumihimo Braid (see page 36) to make a Round 8 Braid about ½ in. (1 cm) long without any beads. This will go into an end cap when the braid is finished.

3 Start releasing one bead at a time with every move of the beaded threads, and continue until the braid is 8 in. (20 cm) long, or the length desired.

4 Work another ½-in. (1-cm) section without any beads.

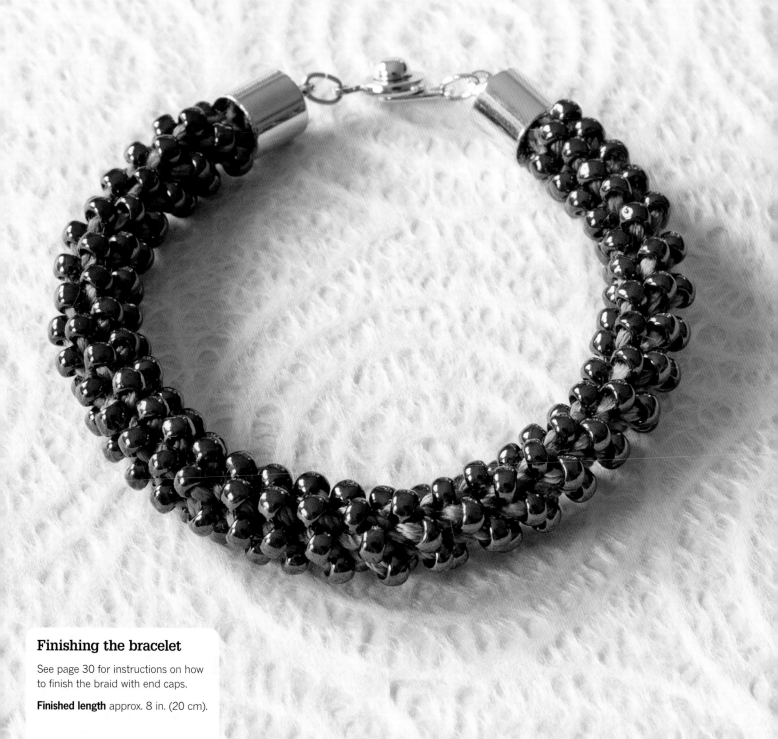

Finishing the bracelet

See page 30 for instructions on how to finish the braid with end caps.

Finished length approx. 8 in. (20 cm).

Rainbows and Dewdrops Bracelet

Once you've mastered the basic Round 8 braid, you'll find working with different beads is a lot of fun. Magatama beads interspersed with tiny gold beads make up this gorgeous bracelet.

SKILL	DISK
	●

Be a better braider

- When using magatama beads in this project, make sure they are all slanted in the same direction, away from the hole in the disk, as shown.

- To make a 24-in. (60-cm) necklace, you'll need approx. three times the quantity of beads and thread.

- To calculate the length of the braid, deduct the length of the clasp from the total length of the bracelet.

- Use a braiding cord, such as C-Lon, as an alternative to the silk.

You will need

4 yd. (4 m) Exotic Lights silk #31 Lilipilli

30 g of 4 x 7 mm rainbow metallic magatama beads (approx. 270 beads)

2 g size 8 gold seed beads (approx. 90 beads)

8 mm end caps and clasp set

8 small E-Z Bobs

Technique

The beads are threaded onto the silk before you begin and then released one at a time while making a Round 8 braid.

When releasing the beads, make sure they do not go inside the braid. They must be standing up on the outside of the braid. The best way is to move the bead, then make the braiding move. See page 27 for more detailed instructions on releasing the beads.

Preparing the disk and threads

- Cut the thread into four equal lengths and tie them together at the center. Set up the disk in the normal way for a Round 8 braid, with a thread either side of the dots (see below).
- Divide the magatama beads into six piles. Using a beading needle and leader thread (see page 26), slide them onto the threads now in position at 32, 8, 9, 16, 24, and 25.
- Now thread 45 of the size 8 beads onto each of the threads now in position at 1 and 17.
- Wind each thread onto a small E-Z Bob as you go.

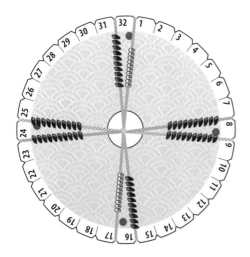

1 Set up the disk as per diagram, by placing threads in positions 32 across to 16, 1 across to 17, 8 across to 24, and 9 across to 25.

2 Follow braiding instructions as for My First Kumihimo Braid (see page 36) to make a Round 8 braid about ½ in. (1 cm) long without any beads. This will go into an end cap when the braid is finished.

3 Start releasing one bead at a time with every move, and continue until the braid is 8 in. (20 cm) long or the length required.

4 Work another ½-in. (1-cm) section without beads.

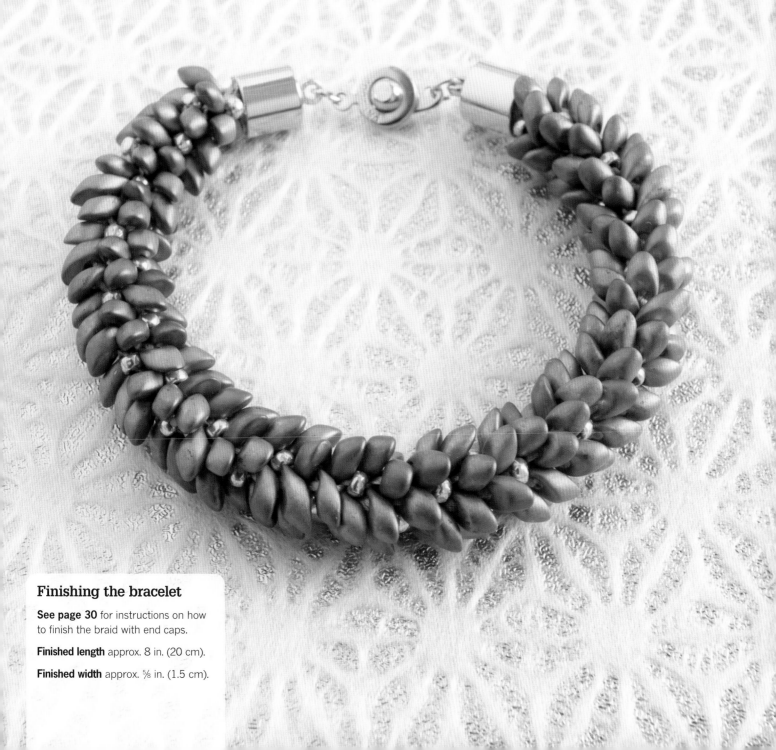

Finishing the bracelet

See page 30 for instructions on how to finish the braid with end caps.

Finished length approx. 8 in. (20 cm).

Finished width approx. ⅝ in. (1.5 cm).

Blue Moon Bracelet

A mixture of magatama and drop beads finished with a delicate heart-shaped toggle makes this elegant bracelet. Beads in different colors form the spiral pattern, and beads in different sizes form the texture.

SKILL **DISK**

Be a better braider

- When using magatama beads, make sure they are all slanted in the same direction, away from the hole in the disk (see page 88).

- Put five or ten beads from each thread on top of the disk at a time. They should be used up at the same rate.

- To make a 24-in. (60-cm) necklace, you'll need approx. three times the quantity of beads and thread.

- To calculate the length to braid, measure the assembled clasp/toggle and deduct this from the finished length desired.

You will need

4 yd. (4 m) Exotic Lights silk thread #34 Arabian Nights

20 g of 4 x 7 mm magatama beads in clear crystal (approx. 160 beads)

20 g of 4 mm drop beads in a blue matte metallic finish (approx. 160 beads)

10 mm end caps and clasp or toggle set

8 small E-Z Bobs

Technique

The beads are threaded onto the silk before you begin and then released one at a time while making a Round 8 braid.

When releasing the beads, make sure they do not go inside the braid. Keep checking that they are standing up on the outside of the braid. The best way is to move the bead, then move the thread. See page 27 for more detailed instructions on releasing the beads.

Preparing the disk and threads

- Cut the threads into four equal lengths and tie them together at the center. Set up the disk in the normal way for a Round 8 braid (see below).
- Divide the magatama beads into four piles. Using a beading needle and a leader thread (see page 26), slide them onto the threads now in position at 32, 1, 16, and 17.
- Divide the drop beads into four piles of the same number and thread them onto the remaining threads at 8, 9, 24, and 25.
- Wind each thread onto a small E-Z Bob as you go.

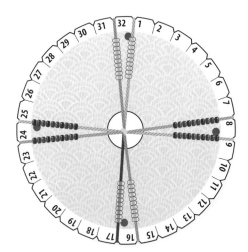

1 Set up the disk as per diagram, by placing threads in positions 32 across to 16, 1 across to 17, 8 across to 24, and 9 across to 25.

2 Follow braiding instructions as for My First Kumihimo Braid (see page 36) to make a Round 8 braid about ½-in. (1-cm) long without any beads. This will go into an end cap when the braid is finished.

3 Start releasing one bead at a time with every move, and continue until the braid is 8 in. (20 cm) long or the length desired.

4 Work another ½-in. (1-cm) section without beads.

Finishing the bracelet

See page 30 for instructions on how to finish the braid with end caps.

Finished length approx. 8 in. (20 cm).

Finished width approx. ⅝ in. (1.5 cm).

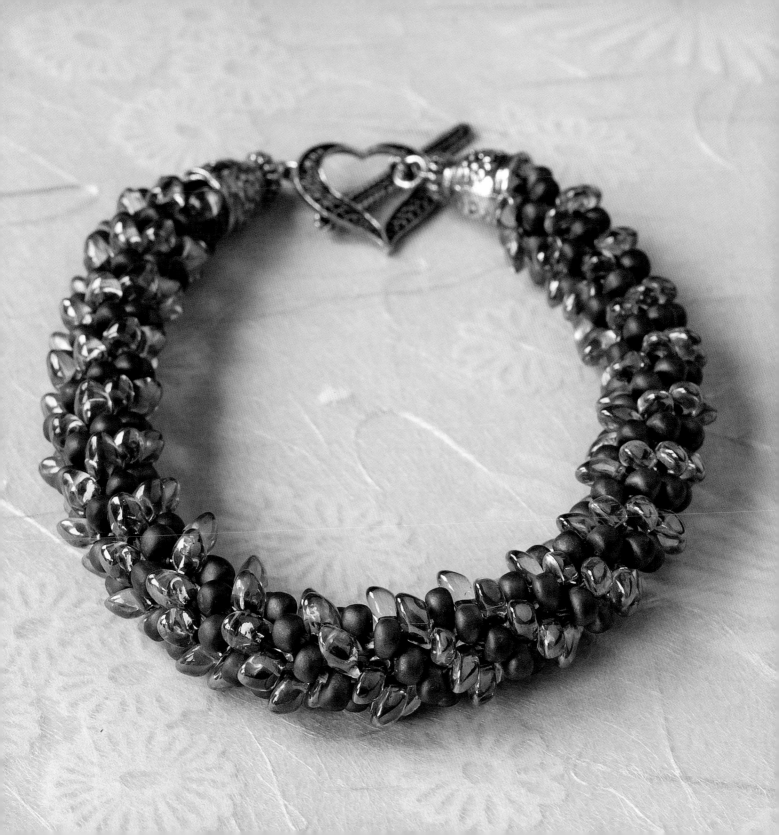

Sea Urchin Bracelet

Dagger beads in striking blue and gold, interspersed with tiny blue seed beads, make this unusual bracelet. This is a Round 8 braid, with beaded threads in eight positions.

SKILL	DISK

Be a better braider

- There is no right or wrong way to thread dagger beads. Just put them on as they are picked up.

- Put five or ten beads on top of the disk at a time. They should be used up at the same rate.

- To make a 24-in. (60-cm) necklace, you'll need approx. three times the quantity of beads and thread.

- Make a plain Round 8 braid and attach one of the beaded bracelets to wear as a necklace.

- Use fine braiding cord as an alternative to silk.

You will need

4 yd. (4 m) Exotic lights silk thread #14 Monet

50 g of blue gold 3 x 11 mm dagger beads (approx. 350 beads)

2 g size 8 blue iris seed beads (approx. 50 beads)

8 mm end caps and clasp set

7 medium E-Z Bobs for the dagger beads 1 small E-Z Bob for the seed beads

Technique

The beads are threaded onto the silk before you begin and then released one at a time while making a Round 8 braid.

When releasing the beads, make sure they do not go inside the braid. They must be standing up on the outside of the braid. The best way is to move the bead, then make the braiding move. See page 27 for more detailed instructions on releasing the beads.

Preparing the disk and threads

- Cut the thread into four equal lengths and tie them together at the center. Set up the disk in the normal way for a Round 8 braid, with a thread either side of the dots (see below).
- Divide the dagger beads into seven piles. Using a beading needle and a leader thread (see page 26), slide them onto the threads now in position at 32, 8, 9, 16, 17, 24, and 25.
- Now thread all of the size 8 beads onto the thread at position at 1 only.
- Wind each thread onto a small E-Z Bob as you go.

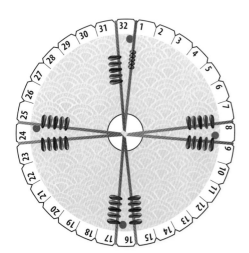

1 Set up the disk as per diagram, by placing threads in positions 32 across to 16, 1 across to 17, 8 across to 24, and 9 across to 25.

2 Follow braiding instructions as for My First Kumihimo Braid (see page 36) to make a Round 8 braid about ½ in. (1 cm) long without any beads. This will go into an end cap when the braid is finished.

3 Start releasing one bead at a time with every move, and continue until the braid is 9 in. (23 cm) long or the length desired. This bracelet is longer than normal to accommodate the extra thickness of the dagger beads. Please adjust the length to suit the wearer.

4 Work another ½-in. (1-cm) section without any beads.

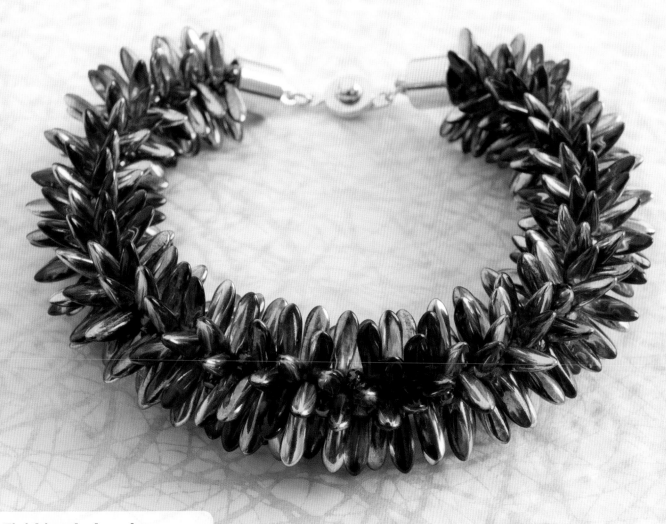

Finishing the bracelet

See page 30 for instructions on how to finish the braid with end caps.

Finished length approx. 9 in. (23 cm).

Finished width approx. ¾ in. (2 cm).

Sweet Georgia Beaded Lariat

The beauty of this necklace is in the colors of the millefiori beads. Add to this a beaded loop and tassel, and you have a truly unique piece of jewelry. This is a Round 8 braid, with four beaded threads for the loop and eight beaded threads for the main part. This braid is especially for my own sweet Georgia.

Be a better braider

- By initially only threading the seed beads for the loop, it's easy to adjust the number of beads needed.

- Use thread that blends in the same colorway as the beads.

- Use very fine braiding cord as an alternative to silk.

- When creating variations of this project, the type of thread used is dictated first by the size of the holes in the beads, and then by your preference for cord or silk.

You will need

16 yd (15 m) Ophir fine silk #2 Water Nymphs

10 strands of 6 mm flat round millefiori beads (approx. 680 beads)

5 g size 11 silver-lined aqua seed beads

1 fancy bead cap to hold the tassel

8 medium E-Z Bobs

Technique

The project can be divided into three elements: the loop, lariat, and tassel. The beads for the loop are threaded onto four of the braiding threads before you begin and released one at a time during braiding (see page 27 for detailed instructions). Then the fancy beads are threaded onto all eight threads for the main part of the project. The tassel is made when the braiding is finished.

When releasing the beads, make sure they do not go inside the braid. They must be standing up on the outside of the braid. The best way is to move the bead, then make the braiding move.

Preparing the disk and threads

- Cut the thread into four equal lengths and set up the disk in the normal way for a Round 8 braid.
- Using some strong beading thread, tie the threads together at the center. This tie will be used to stitch the loop in place.
- To begin the loop, thread approx. 40 seed beads onto each thread now in position at 32, 1, 16, and 17.
- Wind the threads onto E-Z Bobs as you go.

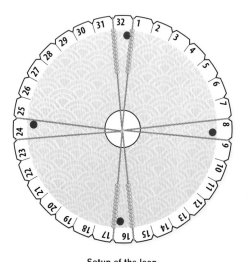

Setup of the loop

1 Set up the disk as per diagram, by placing thread in positions 32 across to 16, 1 across to 17, 8 across to 24, and 9 across to 25.

2 Follow braiding instructions as for My First Kumihimo Braid (see page 36) to make a Round 8 Braid about ¼ in. (6 mm) long without any beads.

3 Start releasing one bead at a time, when a beaded thread is moved, and braid the length required for the loop. This will be approximately 2 in. (5 cm). Add or subtract the number of seed beads to make the length needed for your loop.

4 Work another ¼ in. (6 mm) without beads, until the threads are back in the starting position. The tiny plain sections are where the loop will be stitched to the braid.

5 To set up the disk for the main part of the lariat, thread each of the same eight threads with approx. 80 millefiori beads, then rewind them onto E-Z Bobs. Keep a few beads aside for the tassel.

6 Continue braiding, releasing a bead with every move, until the braid is 24 in. (60 cm) long or the length desired.

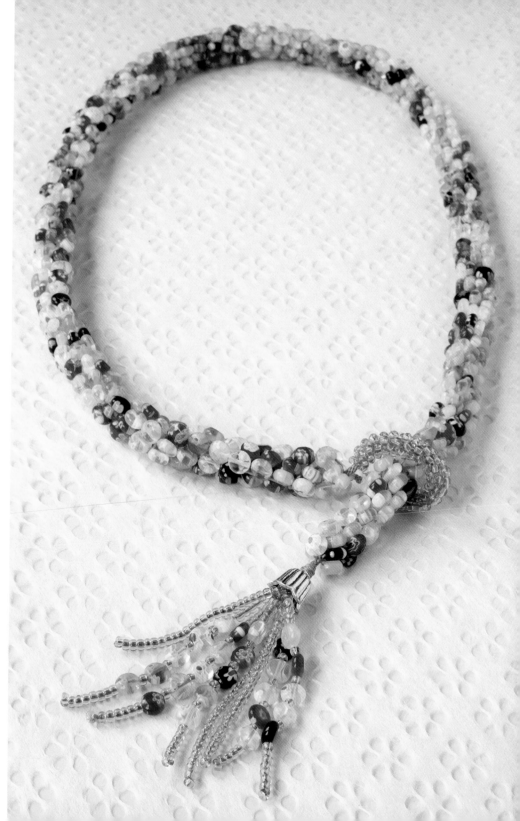

Finishing the lariat

1 Remove the braid from the disk and make an overhand knot at the end of the braiding to secure it.

2 Slide the bead cap over all eight threads, with the small end against the knot. **Tip:** Use a leader thread to do this.

3 Thread a mixture of seed beads and fancy beads onto each of the threads. Start each length with a few seed beads to go inside the cap.

4 Secure the beads in place by passing the thread back up the length of beads, entering at the second last bead. Apply a dab of clear nail polish to the thread where it exits, and trim immediately. Apply a dab of polish on the thread at the end bead.

5 Stitch the loop in place using the tie thread, and anchor inside the braid.

Finished length approx. 24 in. (60 cm) plus tassel.

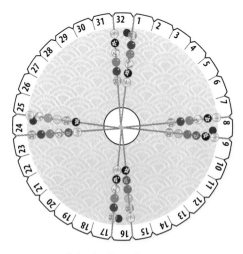

Setup for the main section

Pretty in Purple Beaded Choker

Two braids in one piece! This project combines Round 12 and Round 8 braids and has beads on just four of the threads in the Round 12 section. The positioning of the beads accentuates the spiral pattern of this very pretty braid. This is finished with a connector that can be worn at the side rather than the back.

SKILL	DISK

Be a better braider

- Remember the two chants, "right comes, left goes" and "Move the bead and then the thread."

- Always start and finish beaded braids with a ½-in. (1-cm) plain section to go into the end caps.

- What's a leader thread? It's a needle threaded with a short length of strong sewing thread that has been joined with a reef knot (see page 26). The loop is slipped over a thicker thread and allows the beads to be added more easily.

- Whether the threads are tied with a lark's head knot before they are placed on the disk or tied once the disk is set up, it will still give what's known as a neat end start.

You will need

Using 2-yd. (2-m) lengths of Exotic Lights thread

6 lengths of #17 Jacaranda

4 lengths of #21 Purple Genie

15 g size 8 silver-lined sapphire seed beads (approx. 280 beads)

5 mm end caps and clasp set

12 small E-Z bobs

Technique

The beads are threaded onto the thin threads before you begin and then released one at a time while making a Round 12 braid (see page 27). The plain braid tapers down to a Round 8 braid to finish. The beaded threads are half the thickness of the non-beaded threads. When releasing the beads, make sure they do not go inside the braid. They must be standing up on the outside of the braid. The best way is to move the bead, then make the braiding move.

Preparing the disk and threads

- Place the threads directly onto the disk as follows:
 Jacaranda (single threads) at 32 across to 16 and 1 across to 17.
 Jacaranda (double threads) at 5 across to 21 and 6 across to 22.
 Purple Genie (double threads) at 11 across to 27 and 12 across to 28.
- Tie the center with a scrap piece of thread for a neat-end start. Wind the double threads onto E-Z Bobs.
- Using a beading needle and leader thread, thread one quarter of the beads (approx. 70 beads) onto each of the four single Jacaranda threads and wind onto bobbins as you go.

1 Set up the disk as per diagram and description above. **Note:** Threads at 32, 1, 16, and 17 are single Jacaranda threads and have the size 8 beads threaded. Threads at 5, 6, 21, and 22 are double Jacaranda threads. Threads at 11, 12, 27, and 28 are double Purple threads.

2 Follow braiding instructions as for the Sunset Spiral Necklace (see page 40) to make a Round 12 braid about ½ in. (1 cm) long without any beads. This will go into an end cap when the braid is finished.

3 Start releasing one bead at a time with every move of the beaded threads, and continue until the braid is 10 in. (25 cm) long.

4 Work another section of Round 12 without beads to use up the remaining thread.

5 Continue braiding, using only the thick threads and working as a Round 8 braid (see page 36). The last of the single threads can be trimmed and hidden inside the Round 8 braid.

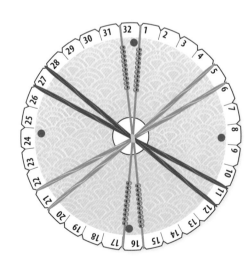

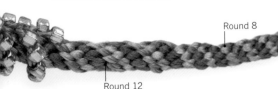

Round 8

Round 12

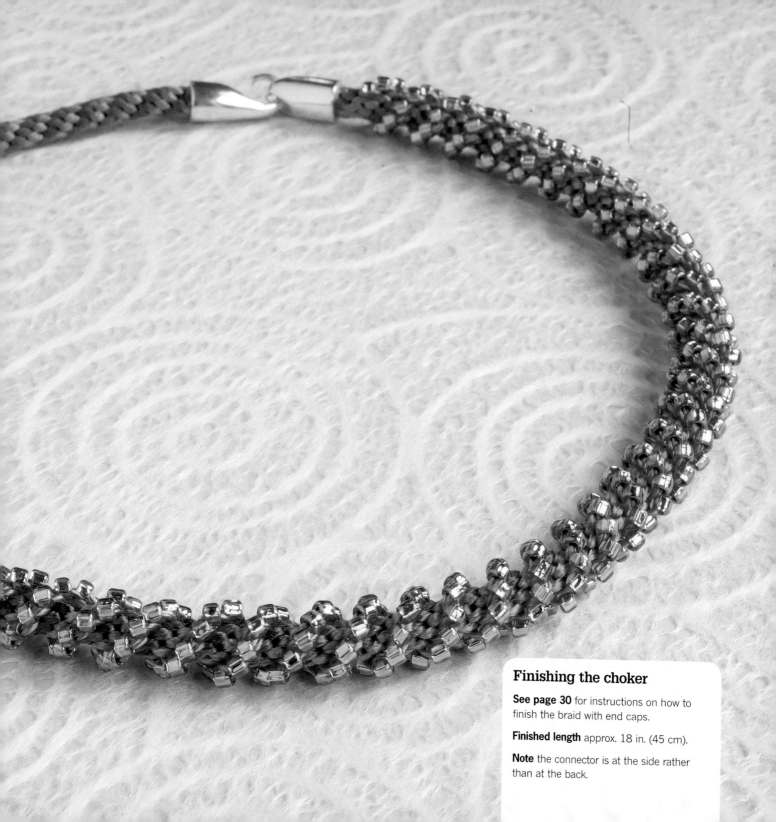

Finishing the choker

See page 30 for instructions on how to finish the braid with end caps.

Finished length approx. 18 in. (45 cm).

Note the connector is at the side rather than at the back.

Pearly Pink Twist Braided Necklace

This is a Round 16 braid, with threads in sixteen positions, and is started with a neat end. The braid is twisted around the string of pink pearls to make this stunning necklace.

You will need

Oliver Twist One Off's #30 Pale Candy Floss containing approx. 10 lengths 4¼ yd (4 m) long

2 strings of 6 mm pale pink (or color to match thread) pearls threaded to a total length of 32 in. (80 cm)

6 mm end caps and clasp set

16 small E-Z bobs

Technique

The braid is made with threads of different textures and is started with a neat end. The two strands of pearls are strung onto pearl-stringing thread or silk.

Preparing the disk and threads

- If using Oliver Twist or similar ropes of thread, select as many or as few individual strands as required to give the desired result.
- Place them straight on the disk for a Round 16 braid (see page 42), tie the center for a neat end start, and wind onto E-Z Bobs.
- These ropes usually contain some metallic threads, which can help to show the spiral pattern in the braid.

1 Set up the disk as per diagram, by placing threads in positions 32, 1, 16, 17, 4, 5, 8, 9, 12, 13, 20, 21, 24, 25, 28, and 29. **Note:** There are two spaces between each pair of threads.

2 Follow braiding instructions as for the Rose Trellis Necklace (see page 42) to make a Round 16 braid about 36 in. (90 cm) long. This will go into an end cap when the braid is finished.

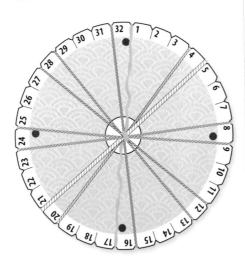

Finishing the necklace

1 Remove the braid from the disk and tie an overhand knot to secure.

2 Anchor the string of pearls to the neat end of the braid, so that the pearls are about ½ in. (1 cm) from the end. **Tip:** Use a bulldog clip on a hook or door knob to hold this end while twisting the braid.

3 Twist the braid around the pearls in the same direction as the spiral pattern in the braid.

4 Anchor the string into the braid at the other end.

5 Whip around the finish end, including the thread of the pearls, and trim all threads. **Tip:** Use the thread the pearls are strung on to do the whipping and anchor it into the braid before cutting.

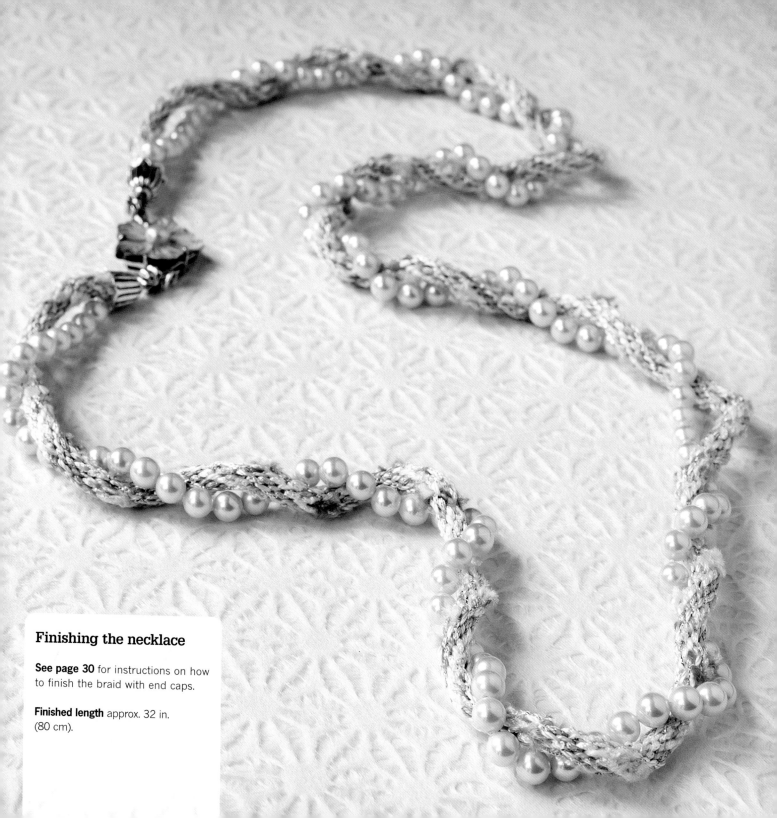

Finishing the necklace

See page 30 for instructions on how to finish the braid with end caps.

Finished length approx. 32 in. (80 cm).

Diamonds Forever Beaded Necklace

This Round 16 project shows off the diamond pattern worked into the braid, with a little picot of beads in the center.

Be a better braider

- Take note of the threads at the point of braiding (see page 22). The two threads on top are the last that were moved.

- Check the picots after every couple of releases to make sure that the three beads are standing up on the outside of the braid.

- The fine thread with the beads is used up quicker than the other threads and therefore needs to be longer to start with.

- If you'd prefer not to cut the Imposter threads in half, use the full lengths to make a longer necklace, or make two braids by cutting the braid in half when it's finished. You'll need twice as many beads to do this. Don't forget to whip around the braid in two places and cut between the whipping (see page 30).

You will need

Using Imposter kumihimo thread 105 in. (2.7 m) long

7 half sections, each 52 in. (135 cm), #46 Turquoise for the background

8 half sections, each 52 in. (135 cm), #53 Pale Sky for the diamond shape

1 length of single-ply thread for the center and beads approx. 1.5 times the length of the other threads, i.e., 72 in. (200 cm)

5 g size 8 platinum beads (approx. 100 beads)

10 g size 8 matte teal beads (approx. 200 beads)

8 mm end caps and clasp set

16 small E-Z Bobs

Technique

This Round 16 braid has thread in 16 positions and is started with an overhand knot. Only the thread at position 8 has beads on it, and three of these are released every time that thread is moved. See page 27 for detailed instructions. The disk is turned counterclockwise to the next pair of threads, and the disk is held throughout.

When releasing the beads, make sure they do not go inside the braid. They must be standing up on the outside of the braid. The best way is to move the three beads, then make the braiding move. See page 27 for more detailed instructions on releasing the beads.

Preparing the disk and threads

- Tie the lengths of thread together at one end with an overhand knot.
- Place the knot in the hole of the disk and the threads around the disk as follows: background (Turquoise) threads at 32, 1, 13, 16, 17, 21, and 24; diamond (Pale Sky) threads at 4, 5, 9, 12, 20, 25, 28, and 29; beaded thread at 8 only.
- Wind all the threads onto bobbins EXCEPT number 8.
- Thread the number 8 thread—the center of the diamond—with size 8 beads in groups of three: 1 teal, 1 platinum, 1 teal. You'll need approx. 100 groups for this length of necklace.
- Wind the beaded thread onto an E-Z Bob.

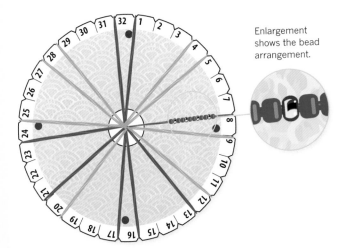

Enlargement shows the bead arrangement.

1 Set up the disk as per diagram and description above.

2 Follow braiding instructions as for the Rose Trellis Necklace (see page 42) to make a Round 16 Braid about ½ in. (1 cm) long without any beads. This will go into an end cap when the braid is finished.

3 Continue braiding until the braid is 22 in. (55 cm), releasing three beads (picot) every time the beaded thread is moved.

4 Work another ½-in. (1-cm) section without beads.

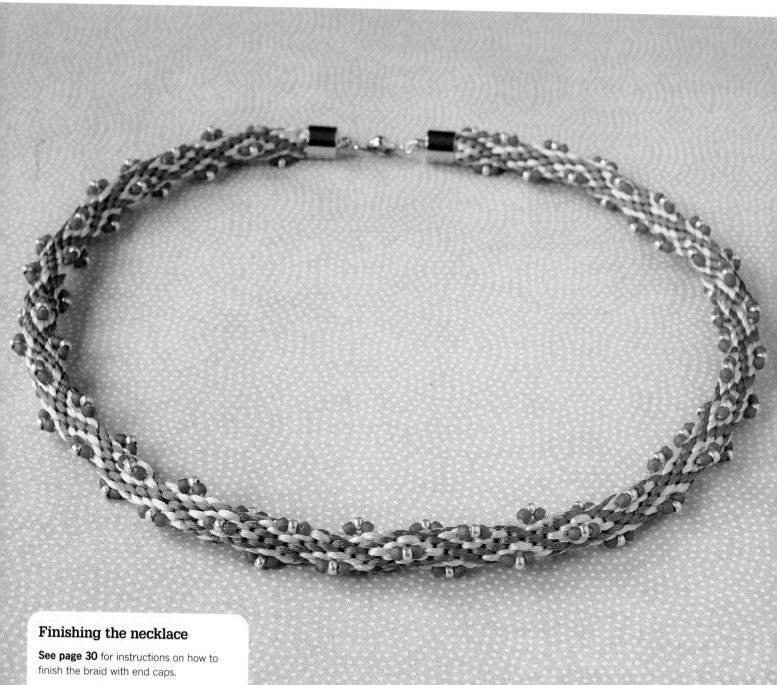

Finishing the necklace

See page 30 for instructions on how to finish the braid with end caps.

Finished length approx. 22 in. (55 cm).

Aventurine Bracelet

This little braid is great for showing off small round aventurine beads. Think of it as a Round 4, with the added beaded thread. Did you know that red aventurine may assist in creativity?

You will need

Exotic Lights #37 Uluru thread 4 yd. (4 m) long

45 aventurine beads 6 mm strung on a 6½-ft. (2-m) length of single-ply thread

3 mm end caps and clasp set

5 small E-Z Bobs
1 medium E-Z Bobs

Technique

This braid is similar to La Plume (see page 46), with the addition of a separate beaded thread that's about one quarter the thickness of the main threads. The beads are threaded onto the braiding cord or silk before you begin and then released one at a time during braiding. See page 27 for detailed instructions. It is started with a neat end. Because the disk is not turned during braiding, the same slots can be used throughout.

Preparing the disk and threads

- Cut the thread into two equal lengths. Fold each length in half to use double, and place onto the disk for a Round 4 braid: 1 across to 17, and 8 across to 24. Place the beaded thread across the disk from 13 to 29, with the beads on one side only, at 13.
- Tie the threads together at the center and wind onto E-Z Bobs, using the medium E-Z Bob for the beaded thread.

Releasing the beads

- Release a bead every time the beaded thread is moved.
- Because the beads are only on one thread, they will be released from one side and then the other.
- Remember to move the bead and then the thread.
- Hold the work under the disk, with your thumb and index finger, and let the disk rest on your hand.

SKILL	DISK

Be a better braider

- The secret with this braid is to keep the right-hand crossover moves above the left-hand threads.

- Adjust the tension of the beaded thread just before adding the next bead.

- Fit end caps with a twisting or screwing movement.

- Hold the braided beads in place under the disk with your thumb and index fingernails.

- If using different threads, the main thread should be three or four times thicker than the beaded thread.

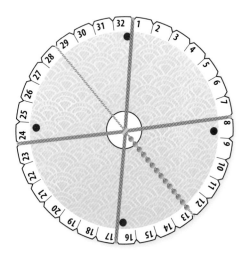

1 Set up the disk as per diagram and description above.

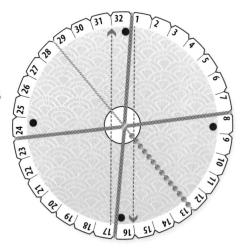

2 Move 1 down to 16 and 17 up to 32.

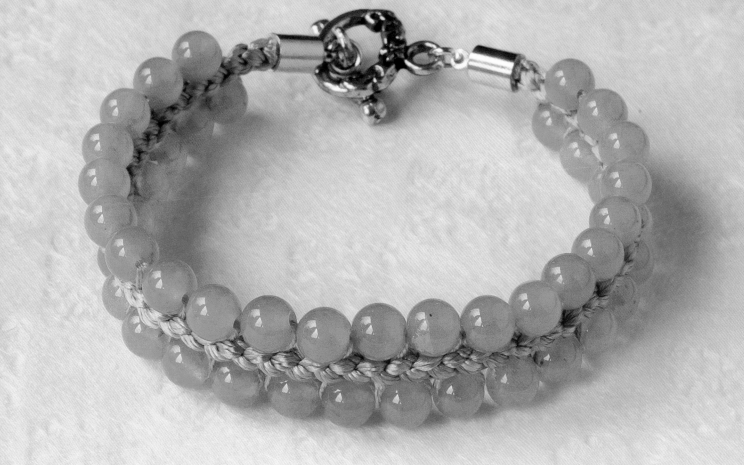

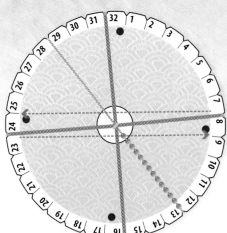

3 Move 8 across to 25 and 24 across to 9.

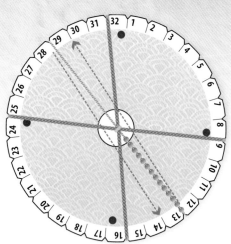

4 Without releasing beads, move 13 across to 30 and 29 across to 14.

Finishing the bracelet

See page 30 for instructions on how to finish the braid with end caps.

Finished length approx. 7½ in. (19 cm).

5 Following the diagrams, braid ½ in. (1 cm) without beads to go into an end cap.

6 Braid 6½ in. (16.5 cm) with beads to create the main part of the braid.

7 Braid another ½ in. (1 cm) without beads to go into an end cap.

Ocean Blue Flat Beaded Neckpiece

The use of triangular beads along the edge of this Flat 8 braid helps shape the braid into an elegant neckpiece.

You will need

4 sections of Imposter kumihimo thread 105 in. (2.7 m) long in #30 Ocean Jade

Or

18 yd. (16.5 m) Exotic Lights hand-dyed silk in #38 Ocean Blue

20 g size 5 emerald triangular beads (approx. 160 beads)

8 mm end caps and clasp set

8 small E-Z Bobs

Technique

This is a Flat 8 braid, with beaded thread in just two positions and plain thread in the other six positions. The braid itself is held under the disk during braiding, with number 1 remaining at the top throughout. The beads are threaded onto the braiding cord or silk before you begin and then released one at a time during braiding.

When releasing the beads, make sure they do not go inside the braid. They must be standing up on the edge of the braid. The best way is to move the bead, then make the braiding move.

Preparing the disk and threads

- If using Imposter kumihimo thread, place each of the four sections directly onto the disk. Use this type of thread if you want the finished necklace to be longer than 20 in. (50 cm)
- If using Exotic Lights or other cut thread, fold four 12-ft. (4-m) lengths of thread in half to use double.
- When you place the threads on the disk, allow an extra few inches on the beaded positions 32 and 1. This is because the beaded thread is used up more quickly.
- Place the thread across the disk as follows: 32 across to 16, 1 across to 17, 8 across to 24, and 9 across to 25.
- Using a needle and leader thread, thread approx. 80 beads on the threads at positions 32 and 1 (see page 26).
- Tie the center, and wind each thread onto an E-Z Bob.

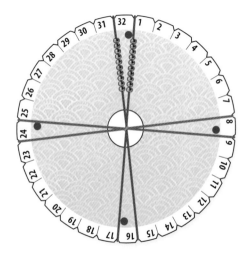

1 Set up the disk as per diagram and description above.

2 Follow braiding instructions as for the Peacock Ribbon Braid (see page 48) to make three complete sequences of a Flat 8 braid without any beads. This will go into an end cap when the braid is finished.

3 Start releasing one bead at a time every time the beaded threads are moved from 9 up to 1, and from 24 up to 32, and continue with the Flat 8 braid until it is approx. 20 cm (50 in.) long. Make sure that the bead is pushed

against the braid and tucks under the thread that's being crossed. Remember to move the bead, then move the thread.

4 Work another three sequences without beads to match the starting end.

Finishing the neckpiece

See page 30 for instructions on how to finish the braid with end caps.

Finished length approx. 20 in. (50 cm).

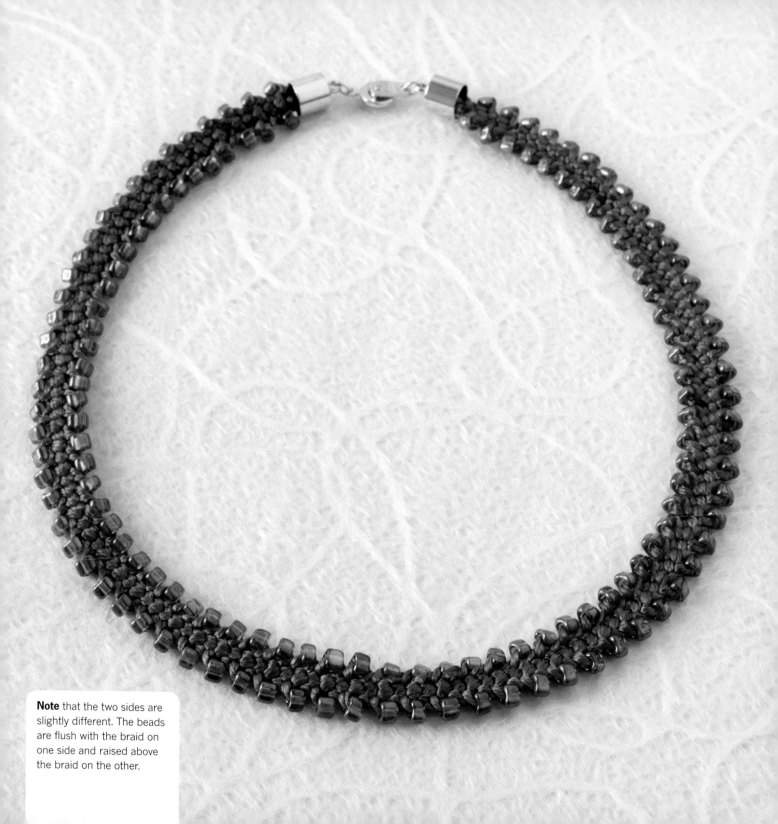

Note that the two sides are slightly different. The beads are flush with the braid on one side and raised above the braid on the other.

Goddess Flat Beaded Neckpiece

The beads are all along one edge of this Flat 8 braid. The seed beads are worked into the braid and the paddle beads added after the braiding is complete. Finish the project with end caps, or a beaded loop and tassel to give it an extra dimension.

SKILL	DISK

Be a better braider

- For this project the threads need to be tied together first, as their positions are not directly opposite each other on the disk.

- Hold the bead and braid under the disk during braiding.

- If you are comfortable using kumihimo thread, you could use an extra section divided into two as the finer thread, i.e. approx. 18 individual threads in each (see page 12).

You will need

Using threads 105 in. (2.7 m) long

2 sections of Imposter kumihimo thread #10 Eggplant

2 lengths of a thinner thread such as Exotic Lights hand-dyed silk #50 Blackberry Ripple

20 g size 6 purple-lined blue seed beads (approx. 240 beads)

46 tanzanite paddle beads (9 x 18 mm)

5 mm end caps and clasp set (optional)

8 small E-Z Bobs

Technique

This is a Flat 8 braid, with beaded thread in four positions and plain thread in the other four positions. The braid is started with a neat end and held under the disk during braiding, with number 1 remaining at the top throughout.

The seed beads are threaded onto the braiding cord or silk before you begin and then released one at a time during braiding.

When releasing the beads, make sure that they do not go inside the braid. They must be standing up on the outside of the braid. The best way is to move the bead, then make the braiding move.

Preparing the disk and threads

- Tie the four lengths of thread—two kumihimo thread and two finer—together at the center.
- Place the tie in the hole of the disk and each section of kumihimo thread at 16, 17, 25, and 8; place the finer lengths at 32, 1, 24, and 9.
- Using a needle and leader thread (see page 26), slide approx. 60 beads onto each of the finer threads at 32, 1, 24, and 9.
- Wind all the threads onto E-Z Bobs as you go. Make sure that all the beads are sitting along one edge of the braid—similar to a zipper.

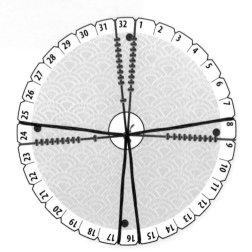

1 Set up the disk as per diagram and description above.

2 Follow braiding instructions as for the Peacock Ribbon Braid (see page 48) to make three complete sequences of a Flat 8 braid without any beads.

3 Continue braiding, releasing a bead every time a beaded thread is moved

from 9 up to 1, and continue until the braid is approx. 26 in. (65 cm) long. Make sure that the bead is pushed against the braid and tucks under the thread that's being crossed. Remember to move the bead, then move the thread.

4 Work another three sequences without beads to match the start end.

Finishing the neckpiece

1 Remove the braid from the disk and initially tie with an overhand knot to secure.

2 Gently stretch the braid over steam to flatten and lengthen (flat braids benefit from this treatment).

3 Using a needle and strong beading thread, sew a paddle bead at approximately every fifth seed bead, missing that bead so it's on top of the paddle. This is also how the paddle beads pleat the beaded side so that it sits nice and flat.

4 Make sure the beading thread is anchored into the braid at each end.

5 See page 30 for instructions on how to finish the braid with end caps.

Finishing with a beaded loop and tassel

1 Follow steps 1 and 2 above.

2 Anchor the beading thread in the start end of the braid, and add some smaller beads to make a loop.

3 Anchor again before adding the paddle beads, as in steps 3 and 4 above.

4 Make a tassel with or without beads at the finish end (see page 32).

Finished length approx. 26 in. (65 cm).

Note that the two sides are slightly different. The beads are raised above the braid on one side and flush with the braid on the other.

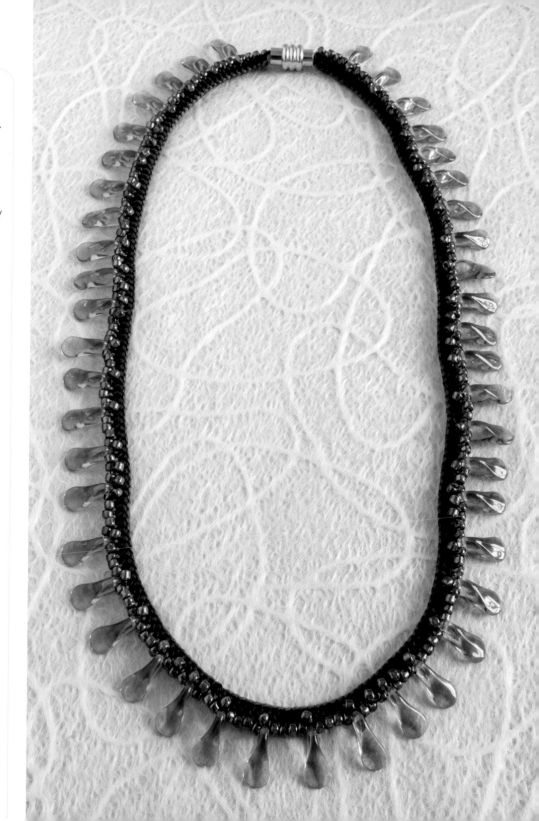

Lace and Beyond Necklace

This is a Square 8 braid, with the beads added from a separate thread, forming little lace picots as they work their way up the sides of the braid. For something "beyond," I've added a beaded rose quartz cabochon.

SKILL	DISK

Be a better braider

- Keep an eye on the beads so that only the correct numbers are released and showing along the sides of the braid.
- To make a larger picot, release five beads at a time.
- Twist the kumihimo threads, keeping them as smooth as possible.
- If you are a beader, bead around a cabochon as in the photo, making the bail large enough to go over the beaded braid.

You will need

2 sections of Imposter kumihimo thread #12 Pale Orchid 105 in. (2.7 m) long

2 lengths of Exotic Lights hand-dyed silk #12 Dawn, or any slightly variegated thread of the same thickness and length

15 g size 8 transparent pink seed beads threaded onto beading thread or fine cord approx. 4 yd. (4 m) long

5 mm end caps and clasp set

Pendant or beaded cabochon of your choice

10 small E-Z Bobs

Technique

This is a square beaded braid that uses the technique of "laying" a string of beads, rather than having beaded warps.

The disk is not turned during braiding—position 1 should remain at the top and the braid itself be held under the disk during braiding. The braid is started with a neat end. See Square Braided Bangle on page 60 for detailed instructions.

Preparing the disk and threads

- Thread the beads onto suitable beading thread using a leader thread, and place across the disk from 13 to 29, with beads on each side. This thread is just a means of carrying the beads into place.
- Place the kumihimo thread from 32 to 16 and 1 to 17, and the remaining thread from 8 to 24 and 9 to 25.
- Tie the threads together in the middle and place the tie through the hole in the disk.
- Wind all the threads onto E-Z Bobs as you go.
- Now, cross 32 and 1, and 16 and 17 as shown in the step 1 diagram.

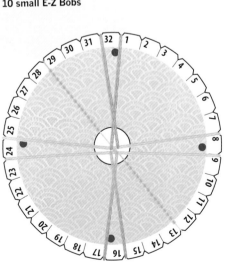

1 Set up the disk as per diagram and description above.

2 Follow braiding instructions as for the Square Braided Bangle (see page 60) to make four complete sequences of square braid without any beads. When you make the moves, make sure you go UNDER the beaded threads. This will carry the beaded thread up to where the first beads are released.

3 Work four complete sequences of the square braid, going OVER the beaded thread. The beaded thread is now coming out of the braid below the point of braiding, and the threads are in the starting position.

4 Slide four beads down to the edge of the braid where the beaded thread is exiting it. Pass the beaded threads to the opposite side of the disk—13 over to 29, and 29 over to 13.

5 Repeat step 3. Release four beads and swap the beaded threads, as in step 4.

6 Continue braiding, repeating steps 4 and 5 until you reach the length required.

7 Finish the braid by working a section without beads to match the start. Don't forget to incorporate the beading thread inside the braid by moving the threads UNDER it.

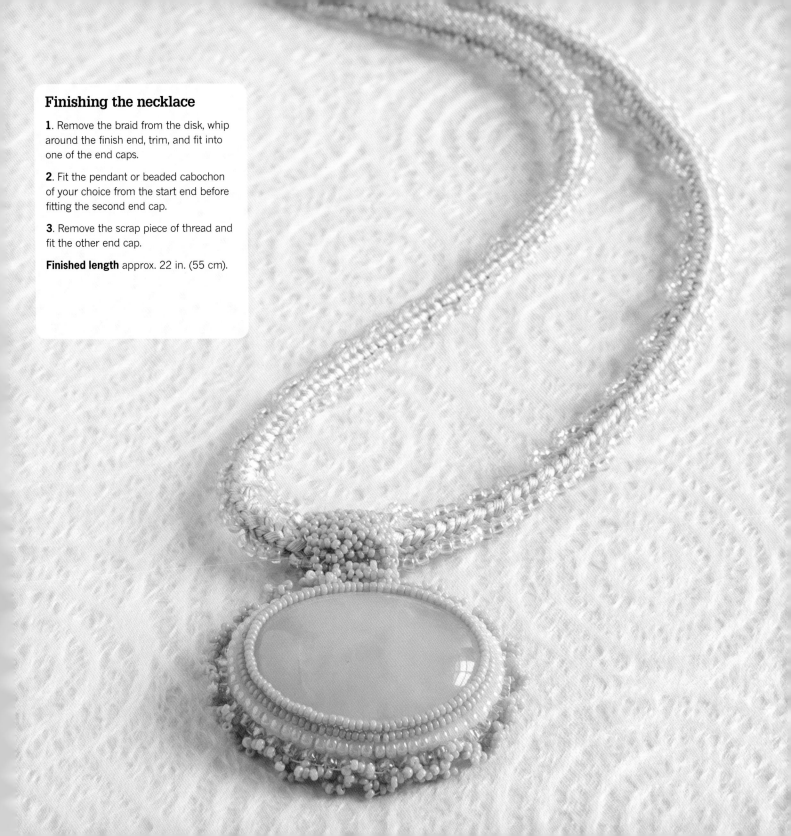

Finishing the necklace

1. Remove the braid from the disk, whip around the finish end, trim, and fit into one of the end caps.

2. Fit the pendant or beaded cabochon of your choice from the start end before fitting the second end cap.

3. Remove the scrap piece of thread and fit the other end cap.

Finished length approx. 22 in. (55 cm).

Blossom Braided Necklace

This is a spiral braid with the addition of some beautiful handmade beads. The braid is worked on its own and then connected to the beaded section, which makes it relatively easy to do.

You will need

- 3 sections of Imposter kumihimo thread #30 Ocean Jade, 105 in. (2.7 m) long

- 2 ft. (60 cm) braiding cord or thread in green to make the beaded section

- 7 handmade beads (approx. 10–12 mm in diameter)

- 20 petal or leaf beads (6 x 8 mm)

- 16 size 8 green seed beads

- Two 4 mm end caps, each with a jump ring

- Two 6 mm end caps

- 5 mm end caps and clasp set

- 12 small E-Z Bobs

Technique

This spiral braid has threads in 12 positions. The sections of kumihimo thread are divided in half to make six lengths in total. Because there are no beads in the actual braid, you could use any thread of a similar thickness.

Preparing the disk and threads

- Divide each length of kumihimo thread into two lots—approx. eighteen individual threads in each (see page 12).
- Place the lengths straight on the disk as you go.
- Tie the threads together at the center with a lark's head knot (see page 26) and wind them onto E-Z Bobs.

- Hold the braid under the disk throughout—let the disk rest on your hand. The threads will work their way around the disk.

Kumi-calculation
The threads at the top and bottom are used up twice as quickly as the threads at the side. For this project the warps are 52½ in. (1.35 m), resulting in a braid 13 in. (33 cm) long. To make a 26-in. (66-cm) braid, the top and bottom warps will need to be 105 in. (2.7 m) long, but the side lengths remain the same as before—52½ in. (1.35 m) long.

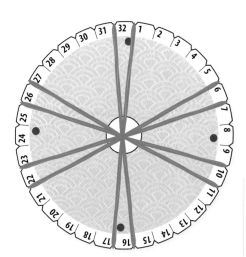

1 Set up the disk as per diagram, by placing sections of kumihimo thread in positions 32 across to 16, 1 across to 17, 6 across to 22, 7 across to 23, 10 across to 26, and 11 across to 27.

2 Follow braiding instructions as for the Twisted Spirals Necklace (see page 58) to make a spiral braid approx. 13 in. (33 cm) long.

Finishing the braid

1 Remove the braid from the disk and whip around the finished end to secure it.

2 Trim all excess threads, apply some clear craft glue, and insert into one of the 6 mm end caps.

3 Remove the tie from the start end, apply some glue, and insert into a matching 6 mm end cap.

4 Whip around the braid, either side of the midpoint, and cut the braid in half between the two lots of whipping (see page 30). Fit the 5 mm end caps with the clasp.

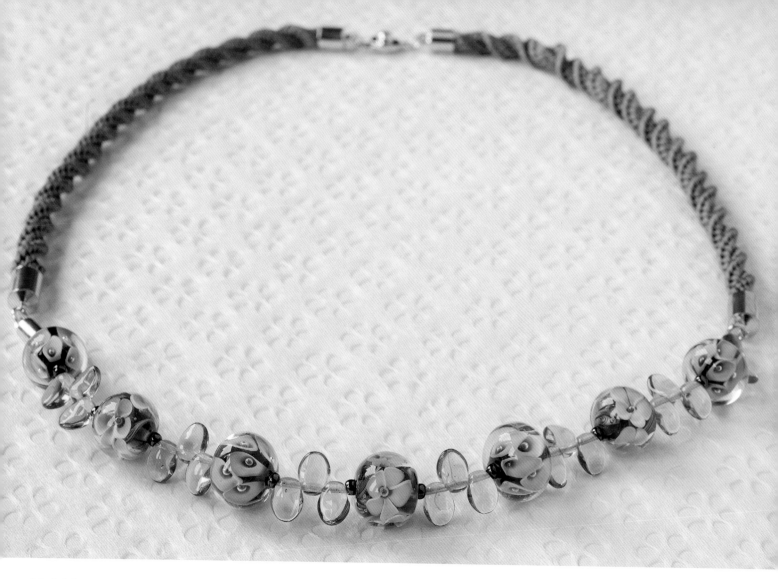

Finishing the necklace

1 Thread all the beads onto the beading cord or thread, in your choice of design, to make a length of approx. 8 in. (20 cm).

2 Knot the end of the thread several times and fit into one of the 4 mm end caps.

3 Finish the other end to match.

4 Use the jump rings on the 4 mm end caps to link the beaded section to the braid (see below).

Finished length approx. 22 in. (55 cm).

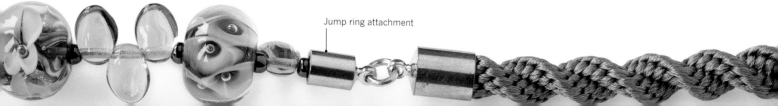

Jump ring attachment

Mystical Flat Beaded Choker

This delicate choker is a Flat 8 braid worked on the square kumihimo plate. The beads pop up on the braid as if by magic. This would also make a lovely bracelet.

Be a better braider

- Make sure the beads are sitting up on the braid.

- For this braid I used Exotic Lights silk in two slightly different shades. You could use pearl cotton #3, as long as the threads at the sides are double the thickness of the threads at the top and bottom of the plate.

You will need

Using Exotic Lights silk thread

4 yd. (4 m) #31 Lilipilli

8 yd. (8 m) #37 Uluru

5 g size 8 gold seed beads (approx. 90 beads)

4 mm end caps and clasp set

8 small E-Z Bobs

Technique

This is a flat braid with thick and thin threads in eight positions on the plate. The beaded threads are only in two of these positions. They are released one at a time, every second time the beaded threads are moved up to the side positions. Hold the braid itself under the plate during braiding.

Preparing the plate and threads

- Fold each length of Uluru thread in half to use double. Place the threads across the plate as follows:
- **Thin threads:** Cut the Lilipilli thread into two equal lengths and place them across the disk from 6 to ⑥ and 7 to ⑦.
- **Thick threads:** Cut the Uluru thread into two equal lengths and fold each in half to use double. Place the double threads across the disk from B to Ⓑ and C to Ⓒ
- Note each warp will be 40 in. (1 m) when the disk is set up.
- Thread approx. 45 beads onto each of the thin threads in positions ⑥ and ⑦.
- Tie the threads together at the center and wind onto E-Z Bobs.

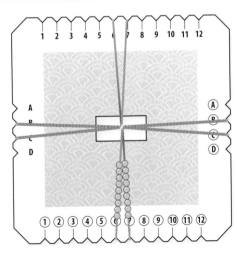

1 Set up the disk as per diagram and description above.

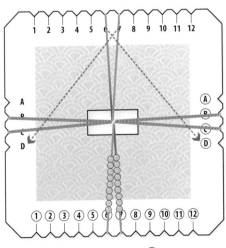

2 Move 6 down to Ⓓ and 7 down to D.

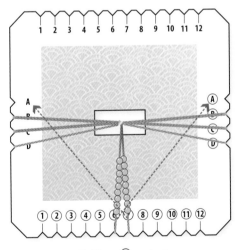

3 Move ⑦ up to A and ⑥ up to Ⓐ.

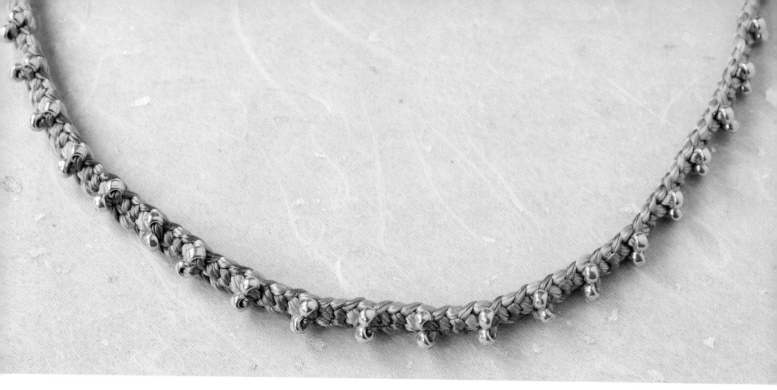

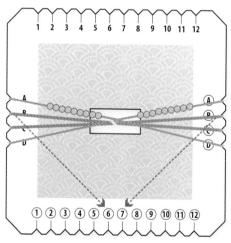

4 Move Ⓑ down to ⑦ and B down to ⑥.

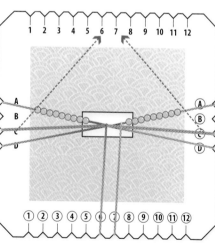

5 Move Ⓒ up to 7 and C up to 6.

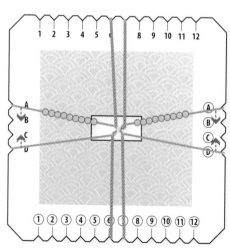

6 Reposition the sides by moving A down to B, D up to C, Ⓐ down to Ⓑ, and Ⓓ up to Ⓒ.

7 Braid until the braid is ½ in. (1 cm) long. This will go into an end cap when the braid is finished. Continue braiding until the braid is 18 in. (17.5 cm) long, releasing a bead every second time the beaded threads are moved up to the sides. Braid another ½-in. (1-cm) section without beads to match the start end.

Finishing the choker

See page 30 for instructions on how to finish the braid with end caps.

Finished length approx. 18 in. (45 cm).

Finished width approx. ¼ in. (6.5 mm).

Beadazzled Free-form Necklace

This is a free-form necklace of beads, beads, and more beads. You can make this into a truly unique necklace by using a mixture of beads in various shapes and sizes, including some silver beads scattered throughout.

SKILL	DISK

Be a better braider

- When threading the beads, make sure they are as mixed up as possible.

- To give the best coverage, release the beads randomly and keep them as close to the braid as you can.

- Make the beaded section a bracelet length and detachable from the main braid. Two sets of end caps and clasps are included in the materials list for this purpose. One of these will act as the clasp for wearing the finished braid.

- The finished length of the beaded section will depend on the sizes and shapes of the beads you use, as they may take up the thread at a different rate and you may release them more or less often than I did with this particular piece.

You will need

Beaded section
13 yd. (12 m) of braiding cord such as C-Lon or mercerized crochet cotton

Approx. 100 g beads in various shapes and sizes, 1 yd. (1 m) long when threaded on the cord

Approx. 30 small silver flower beads

6 small E-Z Bobs and 2 large E-Z Bob for the beads

Plain braid
4 sections kumihimo thread Imposter #25 Cool Red, each 105 in. (2.7 m) long

Two end caps and clasp sets, 5 mm

8 small E-Z Bobs

Technique

This is a Round 8 braid made in two parts. The beaded section is made first and started with a neat end. The beads are threaded before you begin and then released randomly during braiding. The beaded section is attached to a plain Round 8 braid.

Preparing the disk and threads

- Thread the main beads on to a 4-yd. (4-m) length of braiding cord. Make sure the beads are well mixed. **Note:** The beads are quite heavy. You may prefer not to thread them all at the start.
- Place this on the disk from 1 to 17, with half the beads on each side, and wind onto the large E-Z Bobs.
- Divide the remainder of the thread into three equal lengths and position on the disk from 32 across to 16, 8 across to 24, and 9 across to 25.
- Thread the little silver flower beads onto the thread at 32 only.
- Tie at the center, and wind the rest of the threads onto bobbins.

Beaded section

1 Set up the disk as per diagram and description above.

2 Follow braiding instructions as for My First Kumihimo Braid (see page 36) to make a Round 8 braid about ½ in. (1 cm) long without any beads. This will go into an end cap when the braid is finished.

3 Continue braiding, releasing beads as required, until the braid is 9½ in. (24 cm) long or the length desired. The beads don't have to be released every move, but rather randomly. The aim is to have good coverage of the braid so that the thread is hidden as best as possible. Release one of the silver beads any time you think a spot needs filling.

4 Work another ½-in. (1-cm) section without beads.

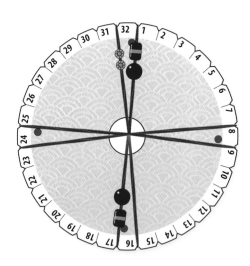

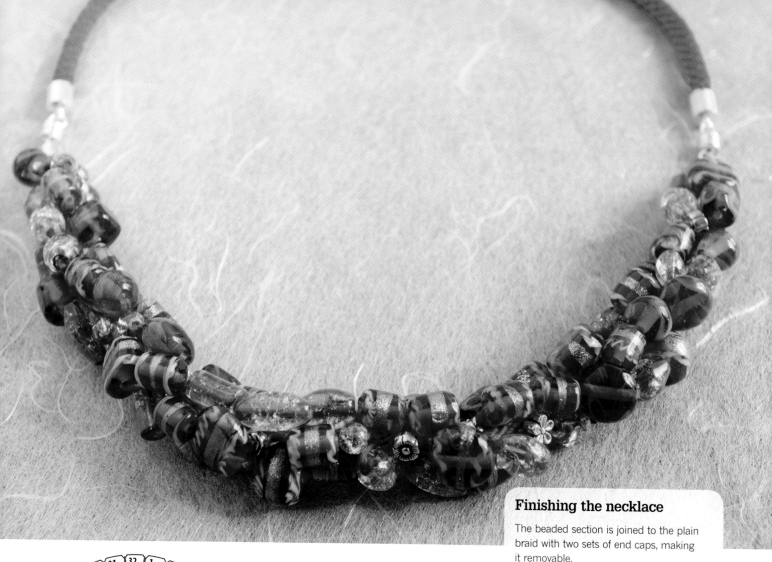

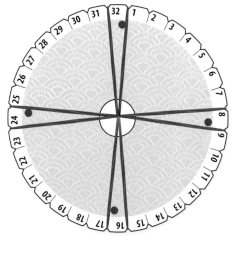

Plain braid

1 Set up the disk as per diagram, by placing kumihimo thread in positions 32 across to 16, 1 across to 17, 8 across to 24, and 9 across to 25.

2 Follow braiding instructions as for My First Kumihimo Braid (see page 36) to make a Round 8 braid about 13 in. (33 cm) long without any beads.

Finishing the necklace

The beaded section is joined to the plain braid with two sets of end caps, making it removable.

1 As you finish each section, whip around the finished end to secure it.

2 Trim all excess threads, apply some clear craft glue, and insert into one of the end caps.

3 Remove the ties from the start end, apply some glue, and insert into the other end cap.

Finished length of beaded section approx. 10 in. (25 cm).

Finished length of necklace approx. 24 in. (60 cm).

Under the Sea Pearl Bracelet

This free-form bracelet is encrusted with pearls and drop beads, making it very lustrous indeed. The beads are released as you desire, making this bracelet one of a kind.

You will need

9 yd. (8 m) Ophir #17 Jacaranda or braiding cord such as C-Lon

1 strand of 8 mm mauve/ purple pearls (approx. 52)

Approx. 120 4 x 6 mm cobalt/vitrail drop beads

4 mm end caps and clasp set

6 small E-Z Bobs
2 medium E-Z Bobs for the pearls

Technique

This is basically a Round 8 braid. Because it's a free-form braid, the pearls and beads are released randomly during braiding.

Preparing the disk and threads

- Thread the pearls onto a 3-yd. (3-m) length of thread and place on the disk from 1 across to 17, with half the pearls on each side. Wind onto medium E-Z Bobs.
- Divide the remainder of the thread into three equal lengths and place on the disk as per diagram.
- Thread the drop beads on the thread now at 32 only and wind onto an E-Z Bob.
- Tie the threads at the center and wind the rest of the threads onto E-Z Bobs.

 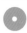

SKILL	DISK

Be a better braider

- Pearls usually have a very small hole, so choose appropriate thread or cord.
- To give the best coverage, keep pearls as close to the braid as you can.
- Try releasing more than one drop bead at a time. This will fill in any plain spots.
- Keeping the moves without beads firm will lock the beads into their place.

Kumi-calculation
To calculate the length to braid, measure the assembled clasp/ toggle and deduct this from the finished length required.

Note regarding length
- The length of thread used will depend on the take-up and release of the beads.
- The length of thread in the materials list is correct for 8 mm pearls strung on fine Ophir thread.

1 Set up the disk as per diagram and description above.

2 Follow braiding instructions as for My First Kumihimo Braid (see page 36) to make a Round 8 braid about ½ in. (1 cm) long without any beads. This will go into an end cap when the braid is finished.

3 Continue braiding, releasing pearls and beads as desired, until the braid is 7½ in. (19 cm) long. The pearls and beads don't have to be released every move, but rather randomly. The aim is to have good coverage of the braid so that the thread is hidden as best as possible. Release up to three drop beads any time you think a spot needs filling.

4 Finish by braiding another ½-in. (1-cm) section without beads.

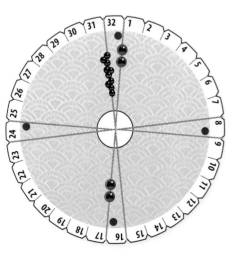

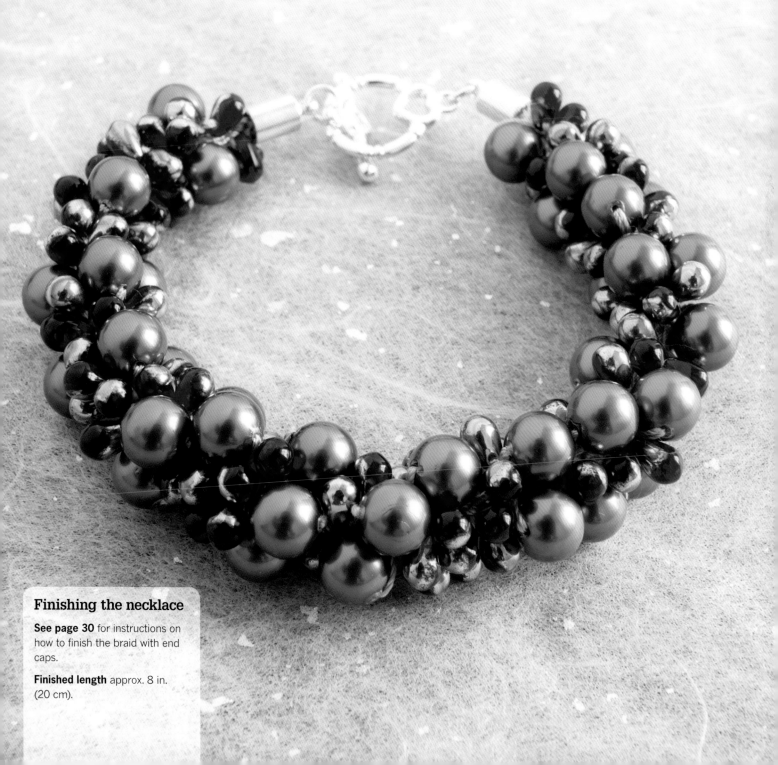

Finishing the necklace

See page 30 for instructions on how to finish the braid with end caps.

Finished length approx. 8 in. (20 cm).

Springtime Buttons Necklace

This fabulous free-form necklace is in all the colors of spring. The buttons are added to a single thread and released during braiding, forming the Round 8 braid into a triangular shape. It can be finished with one, two, or three end-cap sets, making it a versatile necklace.

SKILL	DISK

Be a better braider

- For buttons with an obvious right side, make sure they are all threaded the same way.

- Move three buttons at a time to the top of the disk. When these are used, miss the next time the button thread is moved. You'll always know where you're up to.

- The buttons should be sitting as close to the braid as possible.

- If you're comfortable separating the kumihimo thread, use 6–10 strands for the buttons instead of a single-ply thread.

You will need

3 sections Imposter kumihimo thread #29 Celadon, each 105 in. (2.7 m) long

4 yd. (4 m) Exotic Lights hand-dyed silk #19 Verde, or any similarly colored single-ply thread, for the buttons

Approx. 90 buttons, ½ –¾ in. (15– 20mm)

1, 2, or 3 end caps and clasp sets, 5 mm

**7 small E-Z Bobs
1 large E-Z Bob for the buttons**

Technique

This is a Round 8 braid with the buttons released during braiding, forming a triangular shape. They are threaded onto the single-ply thread before you begin. The necklace is started with a neat end and can be finished with one, two, or three end caps.

Preparing the disk and threads

- Thread all the buttons onto the single-ply thread.
- Place this on the disk, with the buttons on two-thirds of the thread at position 1 and the other third of single-ply thread at 17.
- Wind the button thread onto the large E-Z Bob.
- Set up the remainder of the disk in the normal way for a Round 8 braid: 32 across to 16, 8 across to 24, and 9 across to 25.
- Tie at the center and wind the rest of the threads onto small E-Z Bobs.

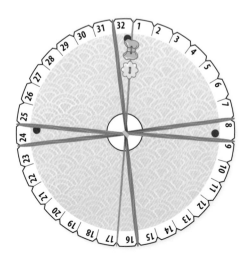

1 Set up the disk as per diagram and description above.

2 Follow braiding instructions as for My First Kumihimo Braid (see page 36) to make a Round 8 braid about ½ in. (1 cm) long without any buttons. This will go into an end cap when the braid is finished.

3 Continue braiding, releasing a button each time the button thread is moved, three times. Miss the fourth time the button thread is moved. This will depend on the buttons you use. You may not have to miss a turn if the buttons are not covering each other too much.

4 Once the buttons are all used, continue braiding as for a normal Round 8 braid until it is approx. 28 in. (70 cm) in length.

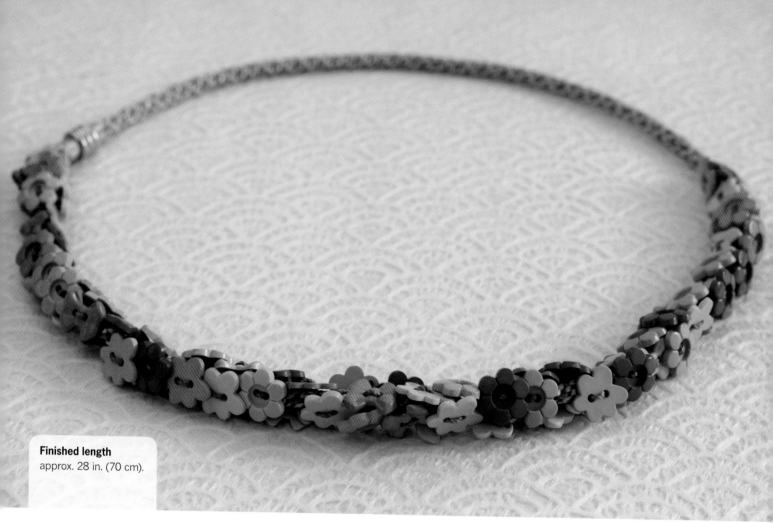

Finished length
approx. 28 in. (70 cm).

Finishing the necklace

1 Remove the braid from the disk, and whip around the finished end to secure it.

2 Trim all excess threads, apply some clear craft glue, and insert into one of the end caps.

3 Remove the tie from the start end, apply some glue, and insert into the other end cap.

To finish with two sets of end caps (see right)

1 Whip around the braid ½ in. (1 cm) from the last button added.

2 Whip around again and cut the braid between the two lots of whipping.

3 Apply the glue, and fit the second set of end caps.

To finish with three sets of end caps (see right)

1 Whip around the braid at the midpoint of the plain braid.

2 Whip around again and cut between the two lots of whipping.

3 Apply the glue and fit the third set of end caps. **Note:** If finishing with three sets, this is the only set that will need a clasp.

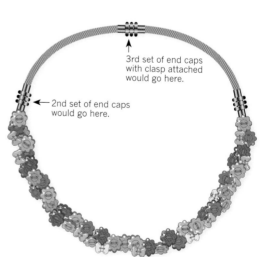

3rd set of end caps with clasp attached would go here.

2nd set of end caps would go here.

Treasure Pearls and Daggers Necklace

This is a free-form necklace featuring keshi pearls, which have the charismatic luster of a true freshwater pearl, combined with copper crystal dagger beads to form a vision of beauty. It is braided in one piece, starting with a Round 8 braid and finished with a beautiful Flat 8 braid, all in metallic kumihimo thread.

SKILL	DISK

Be a better braider

- Pearls usually have a very small hole, so choose appropriate thread or cord.
- Thread the pearls and daggers on different threads so that you can release them as you desire.
- Make the beaded section a bracelet length and detachable from the main braid by using additional end caps.
- Pearls are available worldwide in 16-in. (40-cm) strands.
- The finished length of the beaded section will depend on the take-up and release of the pearls and beads. The length of thread in the materials list should be ample for a longer section.

You will need

4 sections 105 in. (2.7 m) long of metallic kumihimo thread, #M3 Apricot Sparkle

9 yd. (8 m) Ophir #37 Uluru or braiding cord such as C-Lon for the pearls and beads

1 strand of keshi pearls, head-drilled, 5 x 10 mm (approx. 60)

Approx. 150 crystal copper 3 x 11 mm dagger beads

5 mm end caps and clasp set

8 small E-Z Bobs
2 large E-Z Bobs

Technique

The free-form part of this project is a Round 8 braid. The pearls and beads are threaded before you begin and then released randomly during braiding by laying their threads across the main braid. These are independent of the actual braiding moves. Once the beaded section is finished, change to make the Flat 8 braid. The braid is started with a neat end.

Preparing the disk and threads

- Thread the keshi pearls onto a 4½-yd. (4-m) length of braiding cord.
- Thread the dagger beads onto another 4½-yd. (4-m) length of cord.
- Tie these two lengths of cord together and position so that the pearls are at 29 and the dagger beads at 13. Wind onto large E-Z Bobs. The tie will be at the hole and incorporated into the braid when braiding begins.
- Position the metallic thread in the normal start position for a Round 8 braid: 32 across to 16, 1 across to 17, 8 across to 24, and 9 across to 25.
- Create a neat end by tying a scrap thread in the center (see page 29).
- Wind these threads onto small E-Z Bobs.

Free-form Round 8 section

1 Set up the disk as per diagram and description above. Note the beading threads across the disk at 13 and 29.

2 Follow braiding instructions as for My First Kumihimo Braid (see page 36) to make a Round 8 braid about ½ in. (1 cm) long without any beads. This will go into an end cap when the braid is finished. Work the braid around the bead threads so that those threads are inside the braid. Take these threads to the outside when you are ready to start releasing the beads.

3 Continue braiding, releasing beads as required by swapping the bead threads from side to side: 13 to 29 and 29 to 13.

Randomly release the pearls, one at a time. Release the dagger beads to fill in any gaps. This will be between one and three at a time. The beads are not released every move, but rather randomly. The aim is to have good coverage of the braid. In this project the braid is visible between the beads, but it blends in.

4 Continue until all the pearls and beads are used, then work another ½-in. (1-cm) section without beads, working around the bead threads as you did in step 2.

Flat braid section

5 Follow braiding instructions as for the Peacock Ribbon Braid (see page 48) to make a Flat 8 braid and continue until the entire braid is 23 in. (58.5 cm) long.

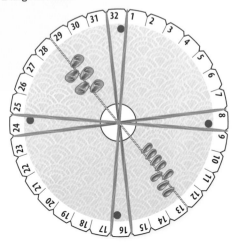

Finishing the necklace

1 See page 30 for instructions on how to finish the braid with end caps.

2 If necessary, anchor any excess bead thread inside the braid and trim.

Finished length approx. 24 in. (60 cm).

Flowers in Spring Neckpiece

This is a project for all levels. The Round 8 braid is twisted and turned, in either a free-form or a balanced shape, to hold all these beautiful roses.

You will need

Using threads 105 in. (2.7 m) long

6 sections of Imposter kumihimo thread, #10 Eggplant

2 lengths of Exotic Lights #50 Blackberry Ripple, or any slightly variegated thread the same thickness as the Imposter

5 rose cabochons, 26 mm

4 tiny roses, 10 mm

5 mm end caps and clasp set

8 small E-Z Bobs

Technique

This is a Round 8 braid, with the flowers added after braiding to shape the necklace. It is started with the threads tied together with an overhand knot. You will need to make a Round 8 braid approx. 52 in. (130 cm) long (see page 36).

Preparing the disk and threads

- Tie the lengths of thread together at one end with an overhand knot and place the knot in the hole of the disk (see tips at right to help with this).
- Position the variegated thread on the disk at 32 and 16.
- Position the Eggplant thread at 1, 8, 9, 17, 24, and 25.
- Wind all the threads onto E-Z Bobs.

1 Set up the disk as per diagram and description above.

2 Follow braiding instructions as for My First Kumihimo Braid (see page 36) to make a Round 8 braid approx. 52 in. (130 cm) in length.

Be a better braider

- When setting up the disk with kumihimo threads of this length that have to be tied with an overhand knot, you may find it easier to place them in position one at a time, with about 6 in. (15 cm) through the hole. Once all threads are in place, tie them together under the disk. This will stop the threads from tangling and separating.

- The threads can then be adjusted on the disk so that they are all smooth before winding them onto the bobbins.

Finishing the neckpiece

1 Remove the project from the disk and tie with an overhand knot.

2 Draw a template of a neck and pin to a cushion or board. A neck stand will work for the template.

3 Decide on the length you'll need from end cap to start of loops, and pin in place as shown.

4 Loop the braid in your design, and pin in place.

5 Rest the flowers in the loops to establish the size and shape of the loops (see left).

6 Use a strong thread to go through the loops with the flowers between.

7 Stitch the tiny flowers in place and anchor the crossover point of the loops. **Optional:** Add a little enamel butterfly as a finishing touch.

See page 30 for instructions on how to finish the braid with end caps and clasp.

Finished length approx. 20 in. (50 cm).

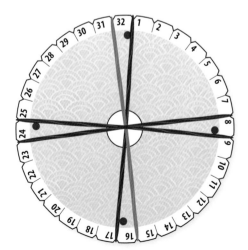

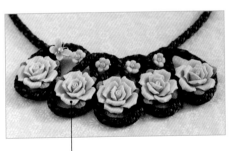

Ideally, the roses should be drilled through the base.

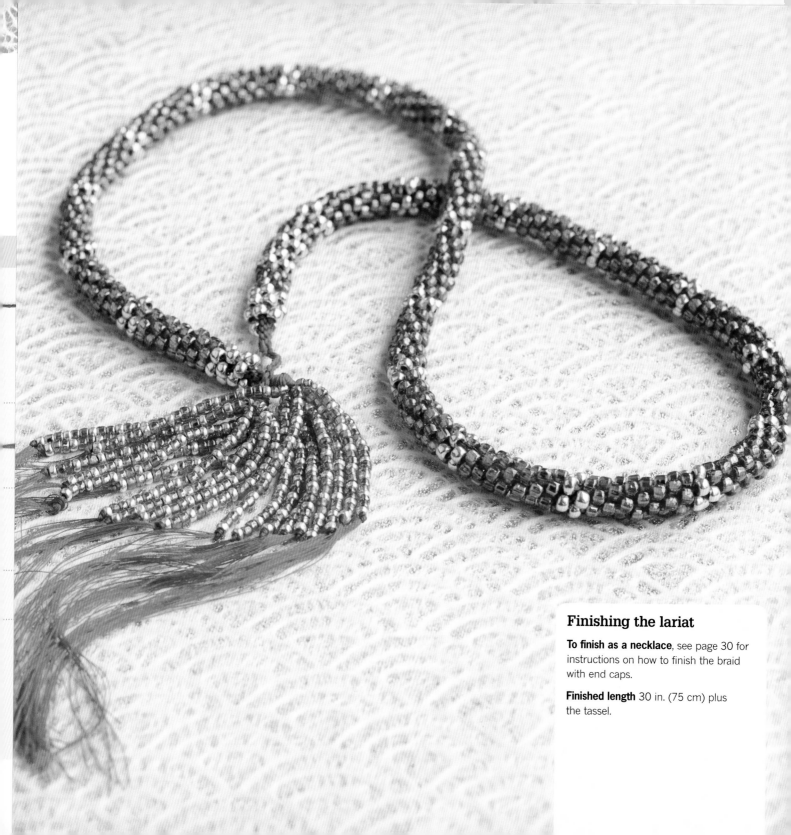

Finishing the lariat

To finish as a necklace, see page 30 for instructions on how to finish the braid with end caps.

Finished length 30 in. (75 cm) plus the tassel.

Index

Templates

Use these templates to make your own cardstock disks. They can be enlarged, or have fewer slots, depending on your needs (see page 10).

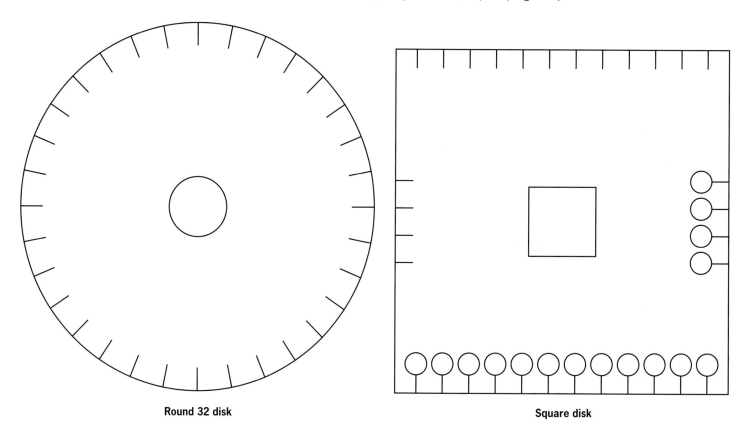

Round 32 disk

Square disk

Credits

A very special thank you to my family and friends for being patient, supportive, encouraging, and always ready for show and tell. I could not have done this without you. Thanks to the team at Quarto, for having the vision for this book. It has been my pleasure to work with you. Thanks to Donna McKean of Riverside Beads *(www. riversidebeads.co.uk)* for being my hands for the step-by-step techniques and supplying some of the tools that logistics prevented me from sending from Australia. I would also like to thank the following, for inspiring me along the way:

Makiko Tada (Japan); Janis Saunders—Braiders Hand (USA) (*www.braidershand.com*); Joanne Ivy—Cranberry Beads (Australia) (*www. cranberry.net.au*); Robyn Alexander—ColourStreams (Australia) (*www.colourstreams. com.au*).

Finally to my students and customers, thanks for your enthusiasm.

All materials used in this book are available individually or in kit form, from Beth at Braid and Bead Studio at *www.braidandbeadstudio.com*.

If you have any queries, or would just like to share your creation, please feel free to email me at: beth@braidandbeadstudio.com.